IMAGES
of America

LARZ ANDERSON PARK

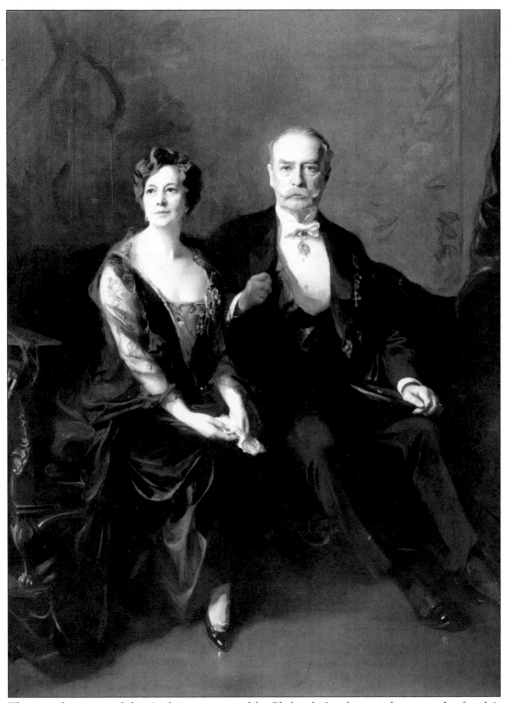

This grand portrait of the Andersons, painted by Philip de Laszlo, now hangs at the family's Washington, D.C., house. The Anderson residence is home to the Society of the Cincinnati, a group founded by Larz Anderson's great-grandfather.

IMAGES
of America

LARZ ANDERSON PARK

Evan P. Ide

ARCADIA

First published 2004

Published by Arcadia Publishing,
Charleston SC, Chicago IL, Portsmouth NH, San Francisco CA

Printed in Great Britain

Library of Congress Catalog Card Number: 2004103631

For all general information, contact Arcadia Publishing:
Telephone 843-853-2070
Fax 843-853-0044
E-mail sales@arcadiapublishing.com
For customer service and orders:
Toll-free 1-888-313-2665

Visit us on the Internet at www.arcadiapublishing.com

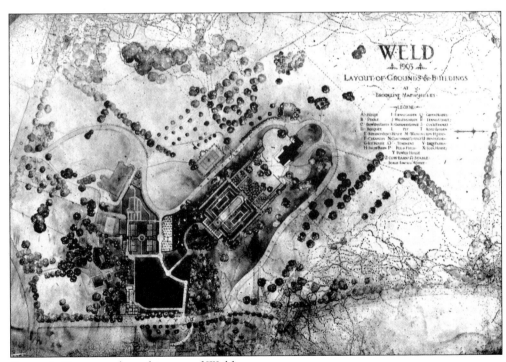

Brown & Company drew this map of Weld.

CONTENTS

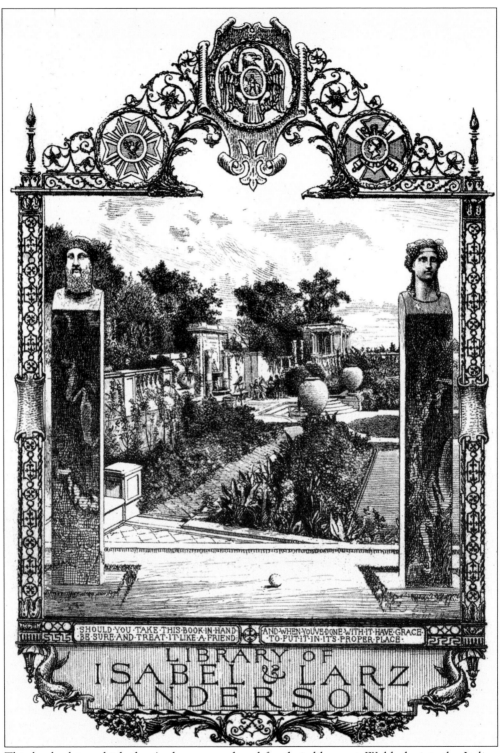

This book plate, which the Andersons produced for their library at Weld, depicts the Italian garden. The symbols above are Larz Anderson's military societies.

INTRODUCTION

This nation has always lacked the pageantry—and the challenge—of the ruling of royal families. The grand royal households and palaces of Europe and beyond are not to be found in the United States. We do, however, vicariously enjoy the lifestyles and estates of prominent and wealthy citizens: early American patriots; entrepreneurs; hotel, shipping, and railroad magnates; industrialists; and software tycoons.

Properties with names like Mount Vernon, Monticello, Biltmore, the Breakers, San Simeon, and Graceland still attract visitors by the thousands every year. Weld, the country estate of Larz and Isabel Anderson, is an important, if less well-known, entry in the nation's portfolio of great American family estates. The property is located just four miles west of Boston in the historic town of Brookline. It predates many of the extravagant "cottages" of Newport, Rhode Island, and most of the 20th century's opulent homes of super-rich industrialists.

Isabel Anderson was a 19th-century heir to a great shipping fortune. At only 12 years of age, she was already America's wealthiest woman with her inheritance of $17 million. In 1899, she married Larz Anderson of Cincinnati, whom she had met while at the American Academy in Rome. The two had an active life together; they never bore children, but took full advantage of life and their personal wealth.

In 1898, Larz and Isabel Anderson set out to build an estate that reflected their lives and experiences together. They shaped the elaborate 64-acre park into a spectacular and very personal place. From its beautiful formal gardens to its more casual sporting fields, the estate was carefully conceived. It was both symbolic of their social position and reflective of their varied tastes.

The park's history begins with Isabel Anderson's maternal grandfather, William F. Weld. His son of the same name soon inherited the property and built the carriage house and the original home. Upon his death, the newly married Isabel Anderson purchased the property from his estate for $300,000. Almost immediately, the Andersons would begin shaping the property to their own desires. The first thing the Andersons did upon purchasing the estate was to name it Weld, in honor of Isabel's grandfather.

The Andersons were romantic people; many of the choices they made in the design of the estate were intended to memorialize important experiences they shared together. They built gardens that reminded them of where they met and honeymooned. Since they both traveled the world extensively, they brought their rich experiences in exotic cultures back with them. Their trips and residence in Asia affected them dramatically, and they surrounded themselves with Asian objects and style.

The Andersons' adventurous spirit led them to one of their strongest passions: the motorcar. First bit by the motoring bug in 1899, they would make the motorcar an important part of their life while building one of the finest collections of early cars in the world. They were so fond of these cars that they hardly sold any, and they eventually opened their collection to the public in the early 1920s.

Weld continued to flourish under the Andersons' care until Isabel's death in 1948. Larz had died in 1933. Having no heirs, Isabel donated the buildings, land, and furnishings to the town of Brookline. Her will requested that the estate be "used for purposes of public recreation, or for charitable purposes, or for purposes of public education." The teams of gardeners and caretakers were gone, so many of the gardens fell into disrepair. But the town park would become a cherished and active part of the community. In 2001, the town of Brookline invested hundreds of thousands of dollars to conserve and restore landscaping and architectural features in the park.

The Andersons' motoring legacy would be maintained at the auto museum housed in their carriage house. The vehicles form one of the oldest and most respected collections in the world. Today, the museum is dedicated as much to preserving the Andersons' history as it is to their automobiles and carriages.

One
A ROMANTIC VISION

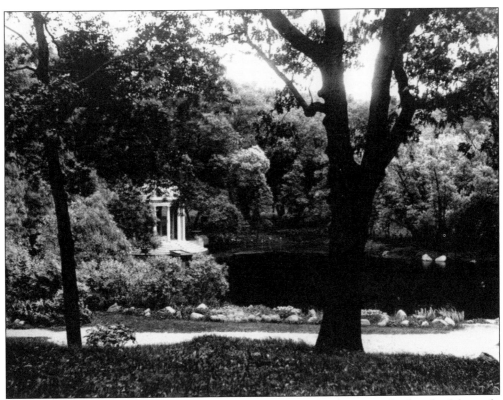

Modeled after the Temple of Love at Versailles, this temple has become a landmark of the park. One of the reasons the Andersons built the temple was to ensure good luck in making a family.

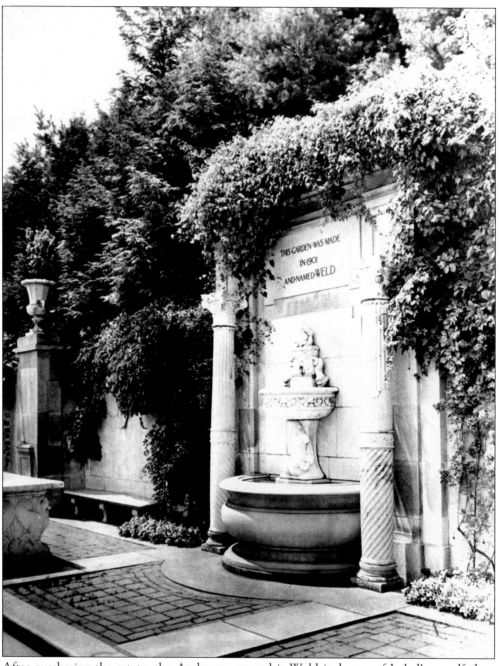

After purchasing the estate, the Andersons named it Weld in honor of Isabel's grandfather. Isabel was the third generation of Welds to live there.

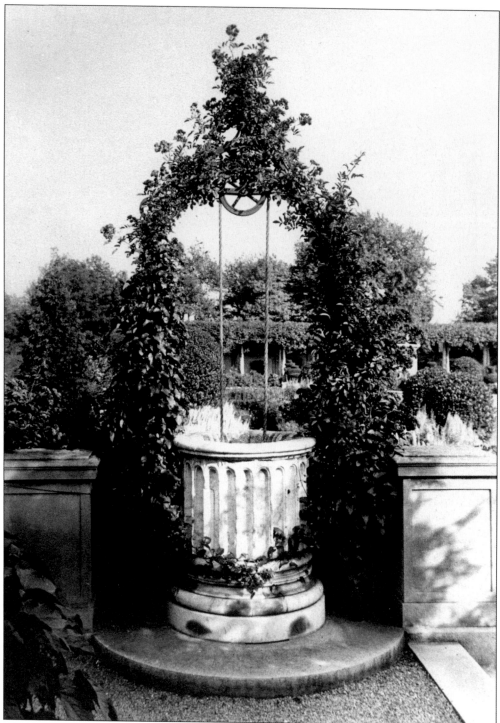

This view of the elaborate well shows the roses winding around the top. The well, originally the source of drinking water for Weld, was transformed into a beautiful feature of the garden.

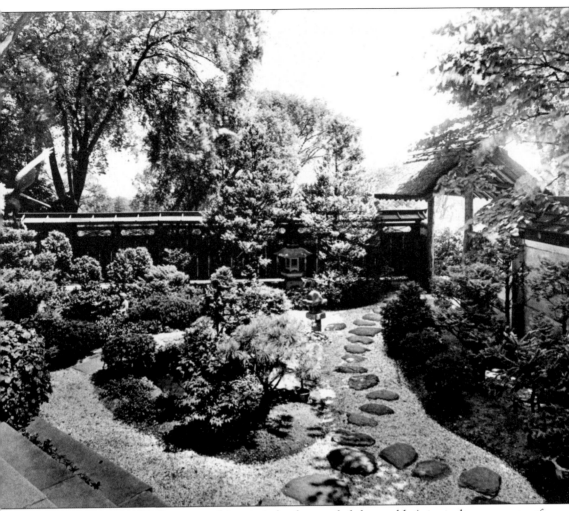

The Andersons, deeply interested in exotic lands, traveled the world. Asian culture was one of their strongest passions. This interest is reflected in the Japanese gardens they built adjacent to the house.

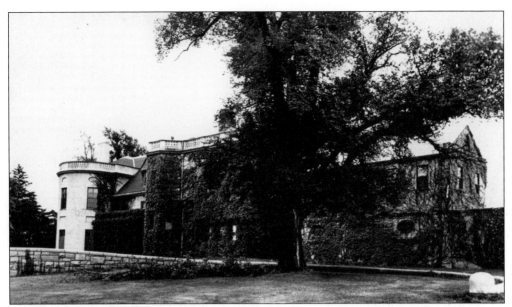

At the top of the estate, the Andersons built an impressive mansion with one of the finest views of Boston. Originally of a shingled New England style, the home was expanded into a much more dramatic and imposing structure.

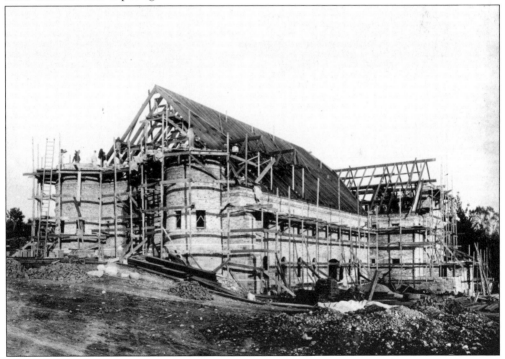

Here, the carriage house is midway through construction. Note the huge timbers used to build the roof. Despite the building's traditional look, it was constructed with many advanced features for the day. The stable room included a ceiling suspended from above with complex metal truss work. William F. Weld built it this way so that the stable area would be free of support pillars.

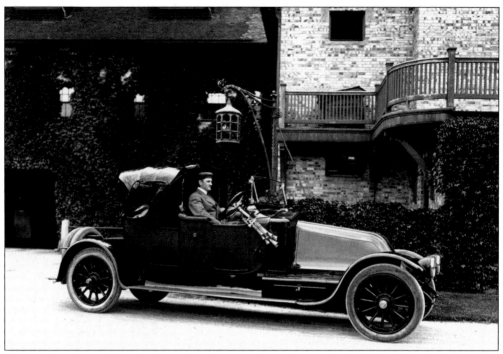

The pride and joy of the Andersons' impressive fleet of cars was this 1912 Renault, a beautiful automobile that they claimed they had a part in designing. Its unique bodywork is striking.

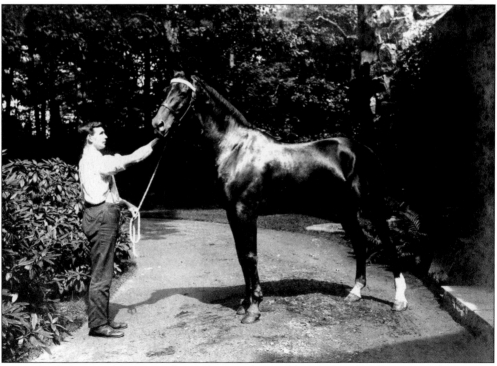

One of Isabel's prized horses is shown here with a stable hand. Isabel kept many horses and actively rode and showed them. She was also quite proficient in driving a team and carriage.

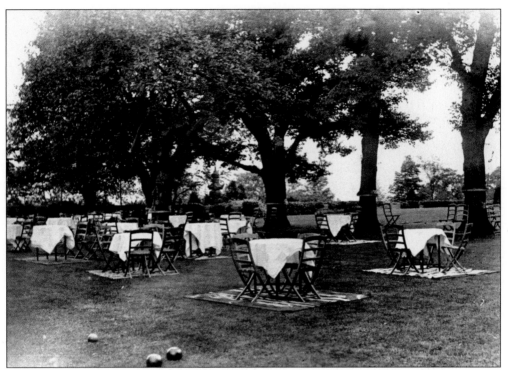

The bowling green is set up with outdoor tables for one of the many functions the couple hosted. The lawn bowling balls are visible in the foreground. Very popular with the younger visitors, the green was one of the sporting facilities added to Weld.

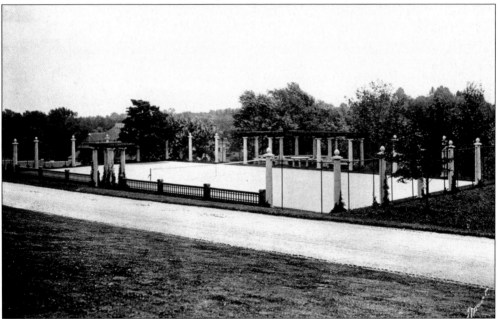

Upon their arrival, the Andersons expanded Weld to include opportunities for sports. In 1902, they hired architects Fox and Gale to design a tennis court by the entrance drive of the estate. It was located to the west of the Italian garden, on the opposite side of the drive.

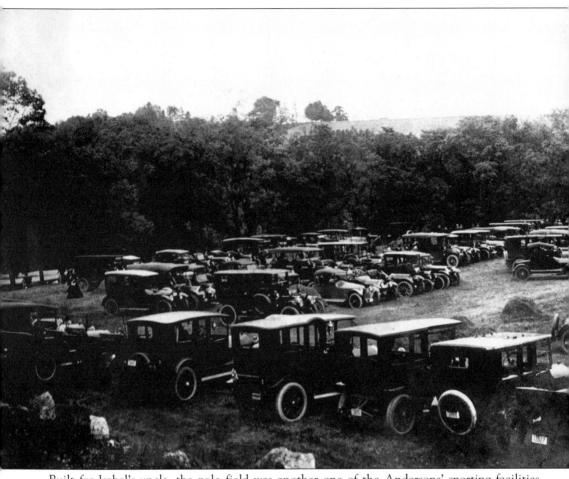

Built for Isabel's uncle, the polo field was another one of the Andersons' sporting facilities. It was designed by Billy Weld, who was a cousin of Isabel and one of the original players for the Myopia Hunt Club. The field was the first private polo field in New England. Isabel claimed another first: the golf course built by her uncle in 1894 is purported to be the first private course in New England. During World War I, the Andersons allowed their polo land to be converted to a potato field in order to help feed the community.

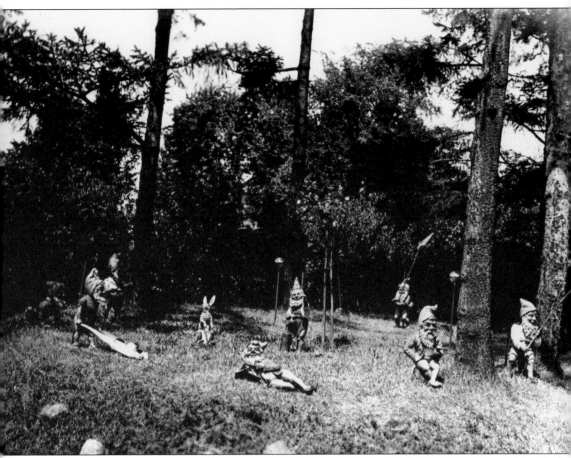

The Andersons collected two generations of ceramic gnomes, minor features composing the woodlands garden. In 1928, Larz replaced an earlier collection from 1917. He wrote:

In my expansive mood I determined to organize another colony of heintzlemenschen, little gnome figures. . . . They had been set out under some pine trees in the upper vegetable garden—terra cotta figures of long-bearded smiling dwarfs—smoking, sitting, digging, lounging—such absurd figures as the Germans love to have in their gardens. Here one meets these small statues unexpectedly in the forests, pointing the way to restaurants or at work among the flowers. My colony at Weld had suffered the usual disasters of age. . . . So I gathered together a new generation of little terra-cotta men to be sent overseas. . . . All would no doubt find a home somewhere in the vegetable garden with the other little menschen.

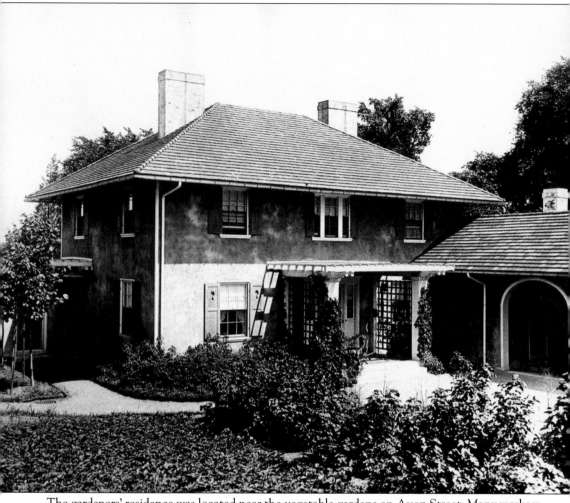

The gardeners' residence was located near the vegetable gardens on Avon Street. Many workers lived at the estate, and the head gardener was lucky enough to live here. Note the bay tree design cut out of the shutters.

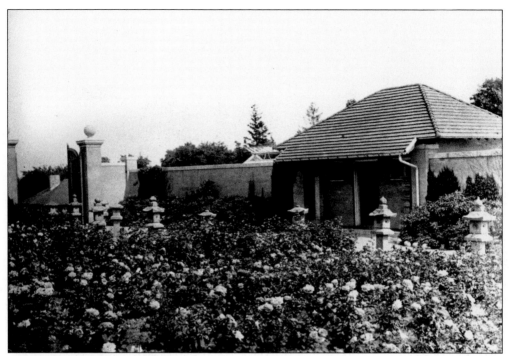

The cut-flower gardens were situated near the rear service entrance to Weld. Note the Asian-style statuary. These gardens were kept to provide fresh flowers to be used in the residence and as gifts for visitors.

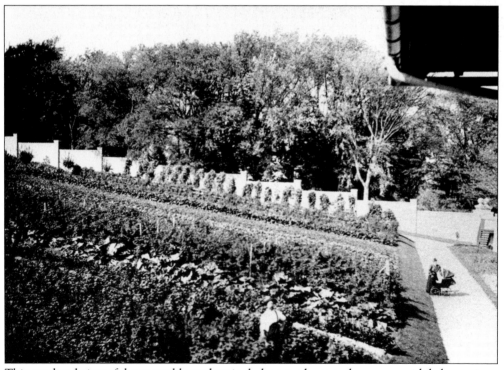

This overhead view of the vegetable gardens includes a gardener and a woman with baby carriage.

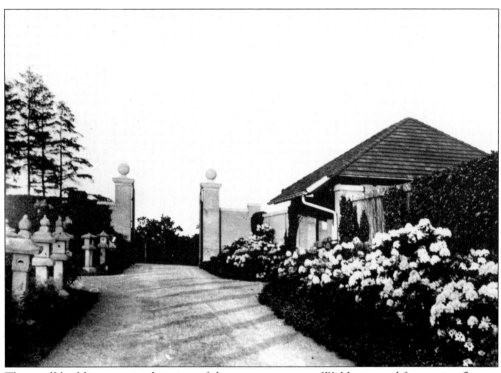

The small building seen in this view of the rear entrance to Weld was used for cutting flowers and harvesting vegetables.

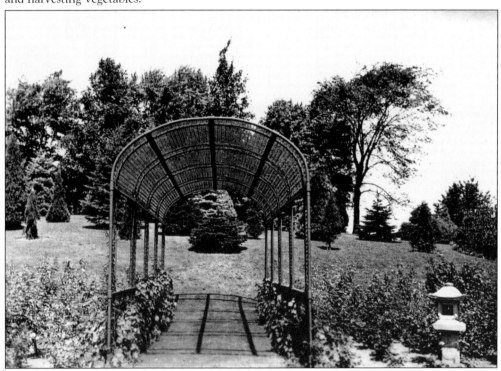

A lattice-type walkway cut through the vegetable gardens.

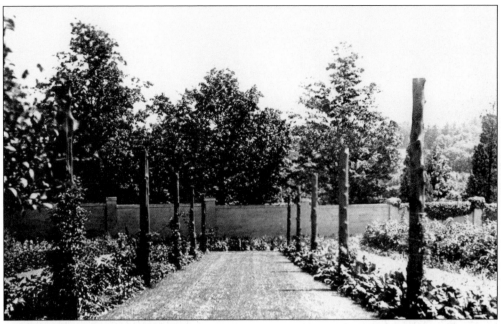

Ample gardens were needed to keep everyone fed properly. The large number of staff required a constant supply of fresh vegetables. Most of the vegetables consumed were grown on site.

As evidenced by these fruitful rose bushes, flowers were an important part of an estate like Weld and were used for decorating the mansion's many rooms.

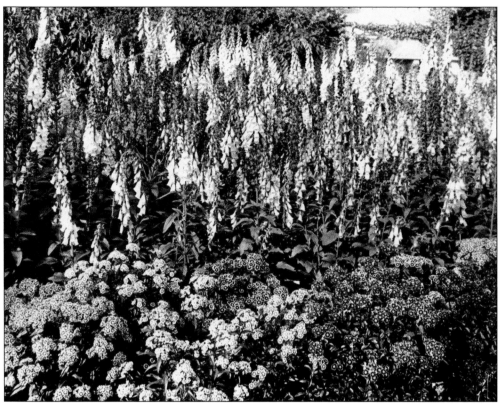

The flower gardens were incredibly bountiful. Isabel was insistent on growing a great variety.

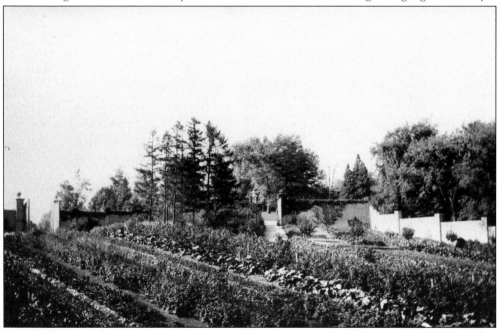

The vegetable gardens were located between the Italian garden and the greenhouses. They were not readily visible from the main drive, as they were more practical than beautiful.

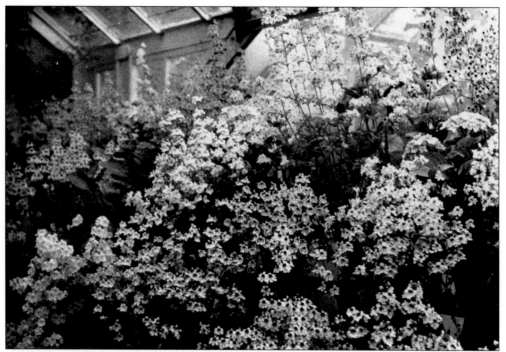

The greenhouses kept flowers growing year-round because the house needed a steady supply during all seasons.

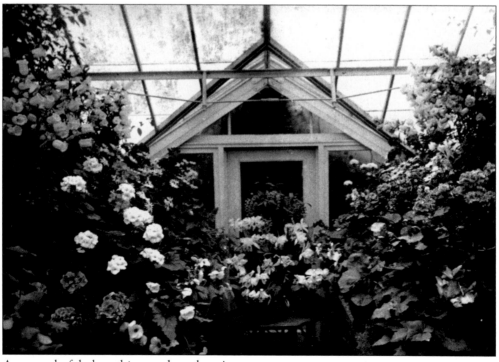

A very colorful place this must have been!

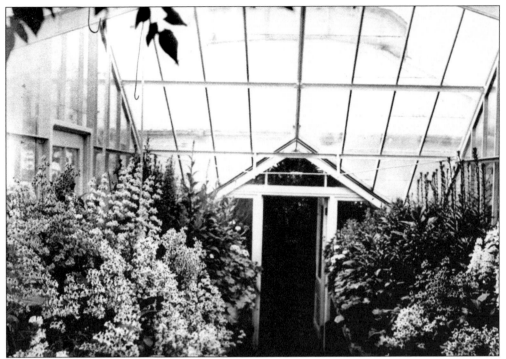

A variety of flowers were cultivated in the greenhouses.

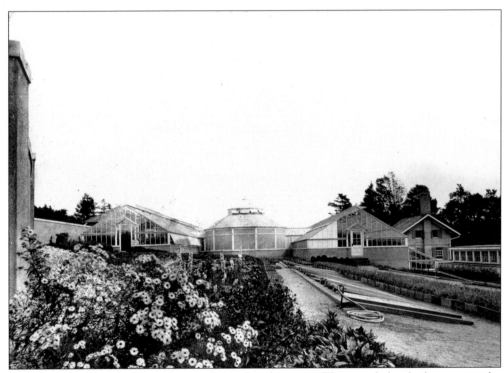

This exterior view of the greenhouses shows their huge size. They needed to be large given the number of plants grown inside them.

The top of the carriage house is seen in the wintertime. The carriage house was home not only to the horses, carriages, and automobiles, but also to the staff. The upper floors were quarters for stable hands, mechanics, and chauffeurs.

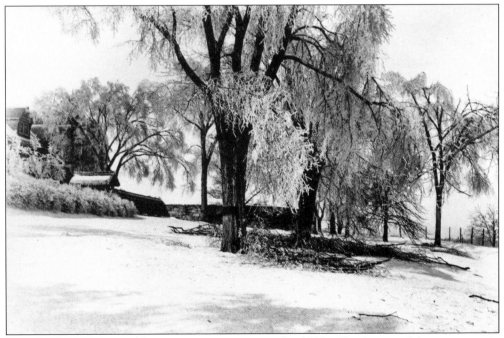

This damage was created by a serious ice storm in the 1920s. Keeping an elaborate estate in New England could prove a challenge.

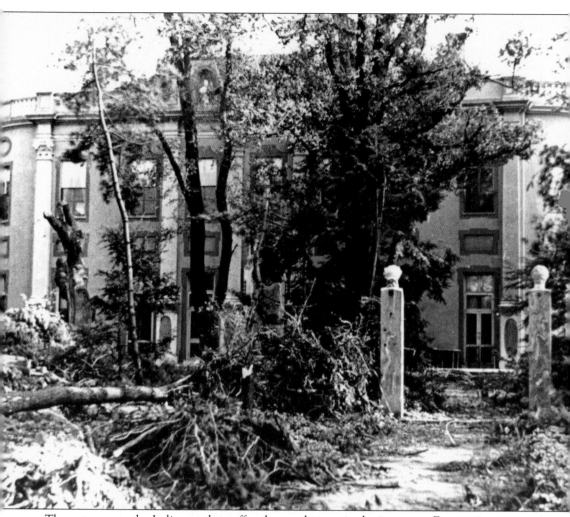

The entrance to the Italian garden suffered more damage in the ice storm. Fierce winter storms would often harm the greenery on the estate. The only trees immune to damage were the bay trees that were put in heated storage during the winter months.

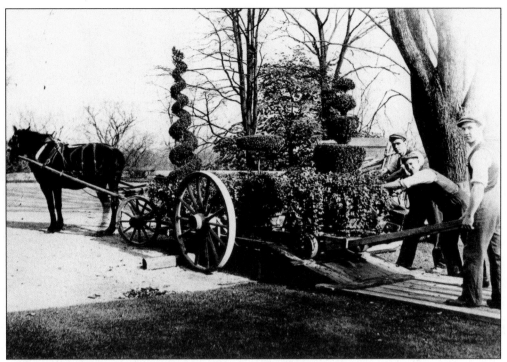

Each year, the gardeners needed to move the greenery from the greenhouses and pits back out into the gardens.

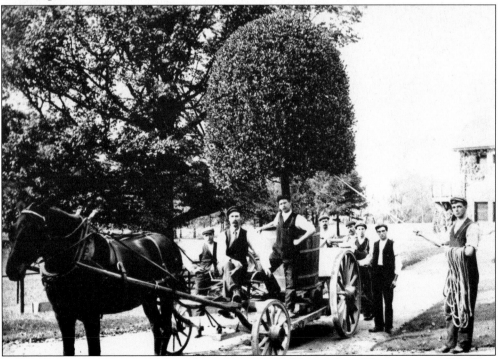

A large bay tree is transported from the pits into one of the gardens. This was no small task, as evidenced by the number of staff on hand.

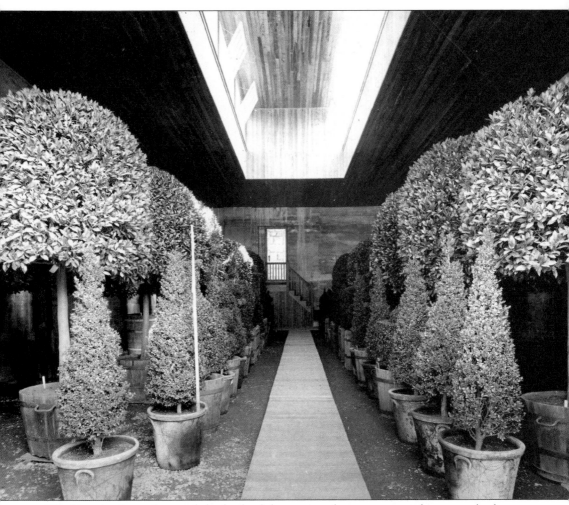

The bay pits, located around the back of the carriage house, were used to store the bay trees over the wintertime. Bay trees are not suited for the New England climate and therefore need to be kept warm in the winter.

Two
EUROPEAN MEMORIES

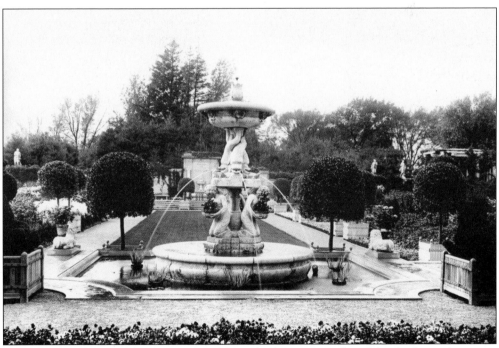

The Italian garden, the showpiece of Weld, was built as a reminder of the Andersons' meeting in Rome. The most personal garden, it was also the most fashionable and socially sophisticated garden at Weld. The chosen site for the Italian garden was the location of the original Weld home built by Isabel's grandfather.

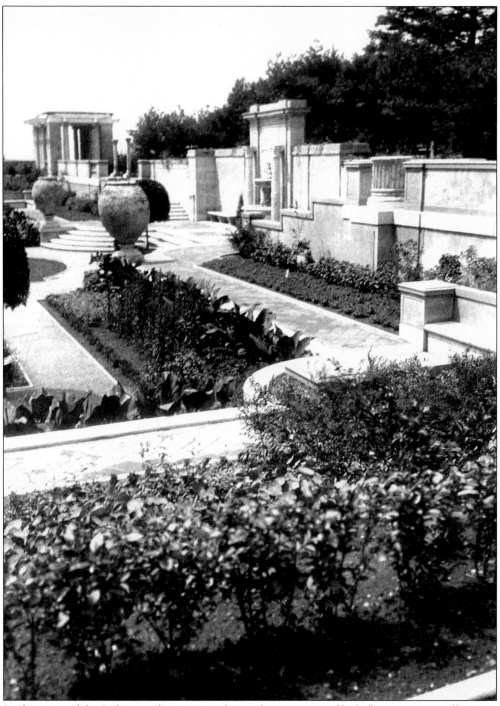

In this view of the Italian garden at its peak, ample quantities of lush flowers are set off against the impressive classical architecture. The Italian style was very popular among the upper class at the turn of the 20th century.

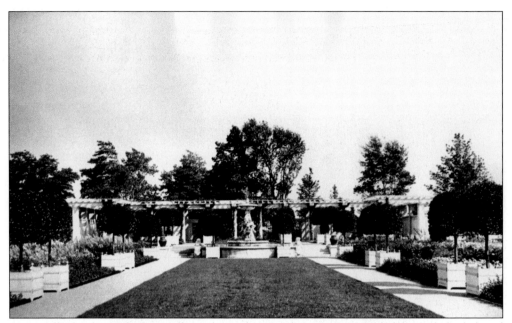

Beautifully landscaped, the mall in the Italian garden was surrounded by Isabel's beloved bay trees.

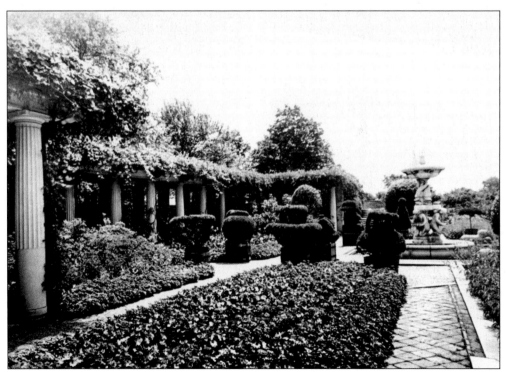

An elaborate trellis and greenery surrounded the Italian garden. This colonnade ran parallel to the drive leading up to the mansion.

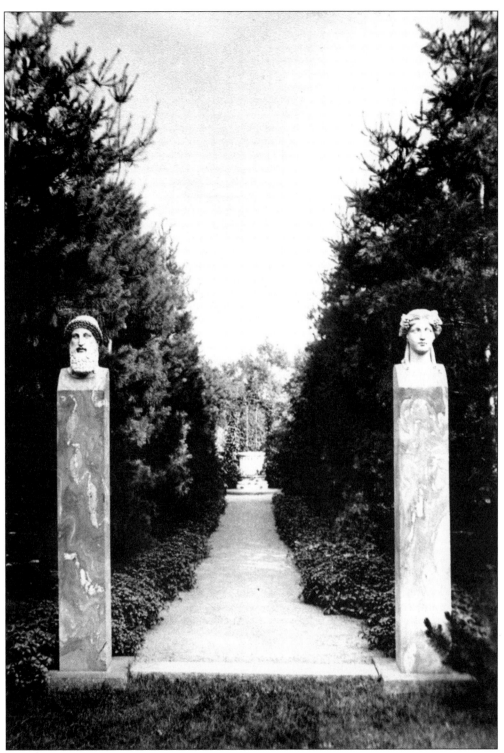

This view looks out into the Italian garden from the front door of the mansion. Roman statuary flanks the entrance path to the garden.

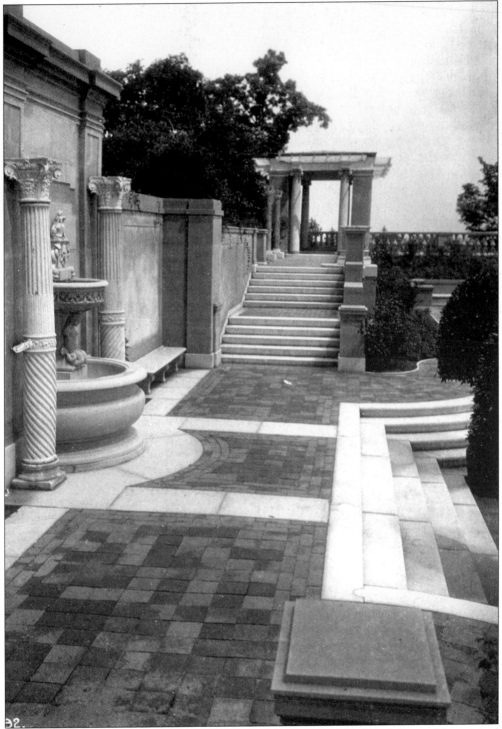

The small colonnaded structure in this photograph marks a memorial to the site of the original Weld home. The Andersons chose to build their most elaborate garden at the site of the home built by her grandfather.

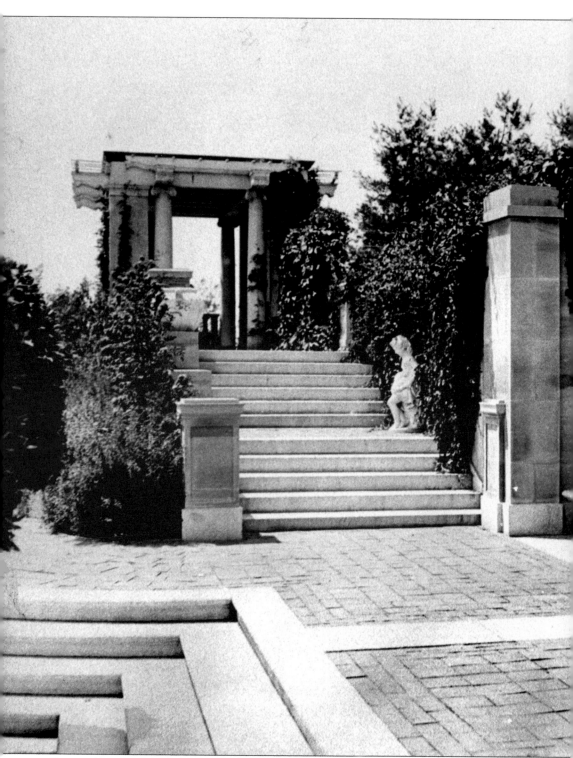

Designed by Charles A. Platt and built in 1901, the garden was an elaborate piece of landscaping and architecture. Clearly, the Italian garden was intended as a sentimental reminder of the

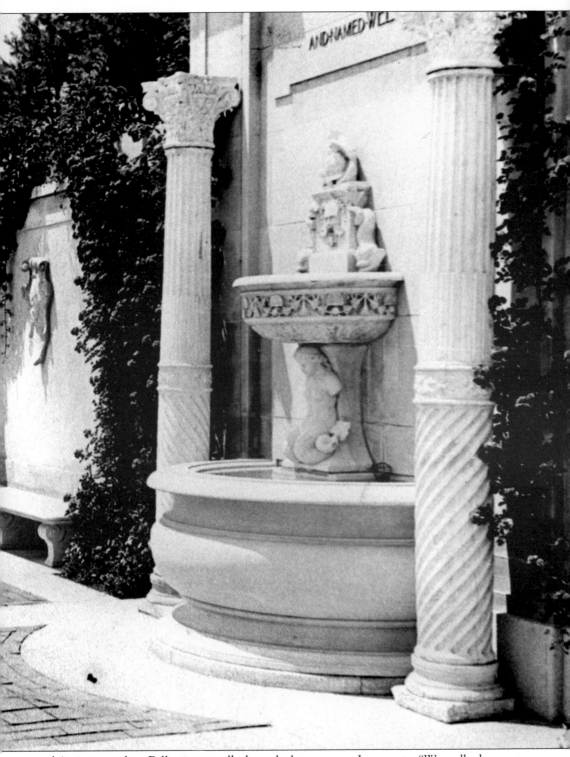

couple's time together. Following a walk through the greenery, Larz wrote, "We walked among the fountains and columns that recalled the blessed times we had spent together. . . ."

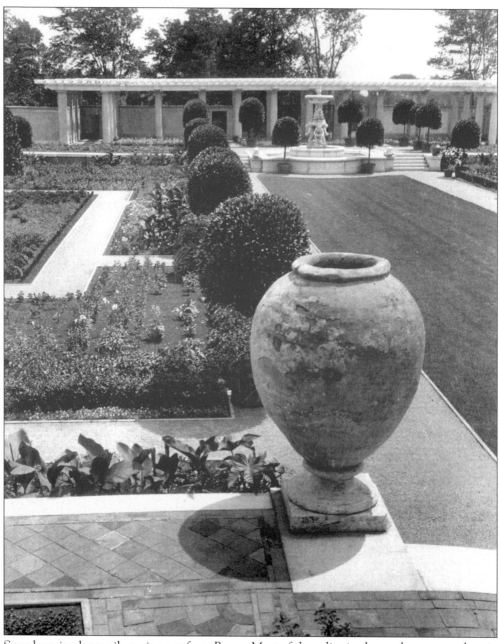

Seen here is a large oil or wine pot from Rome. Most of the relics in the garden were authentic Italian artifacts that the Andersons imported.

Countless flowers and shrubbery were part of the garden. This backside view of the well shows how dense the greenery was. Original to the property, the well was once the only source of drinking water.

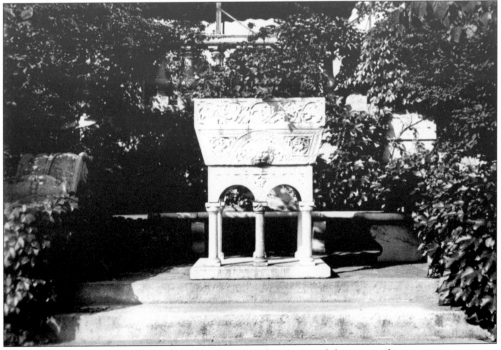

Quiet details like this one added to the charm and serenity of this magnificent estate.

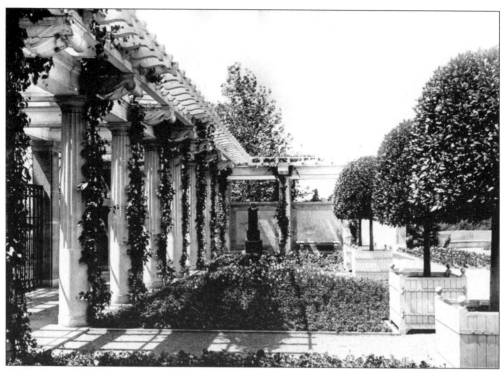

The colonnade is shown at its peak. Exquisitely trimmed bay trees line the right side.

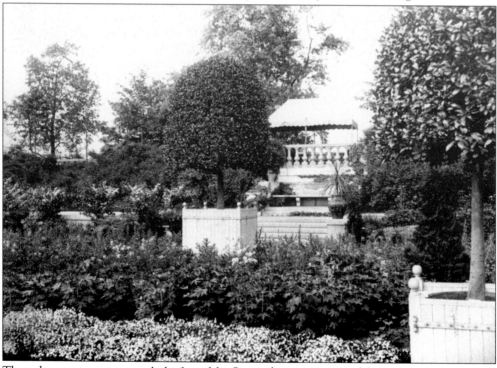

These bay trees were a symbol of wealth. Since the trees required heated accommodations during the winter, their ownership was limited to those who could afford to maintain them.

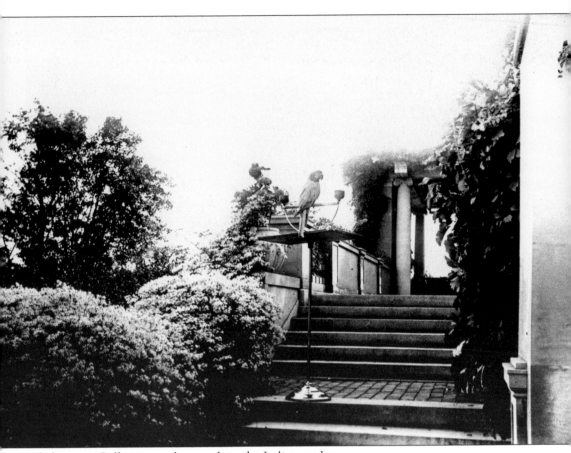

Isabel's parrot Polly rests on her perch in the Italian garden.

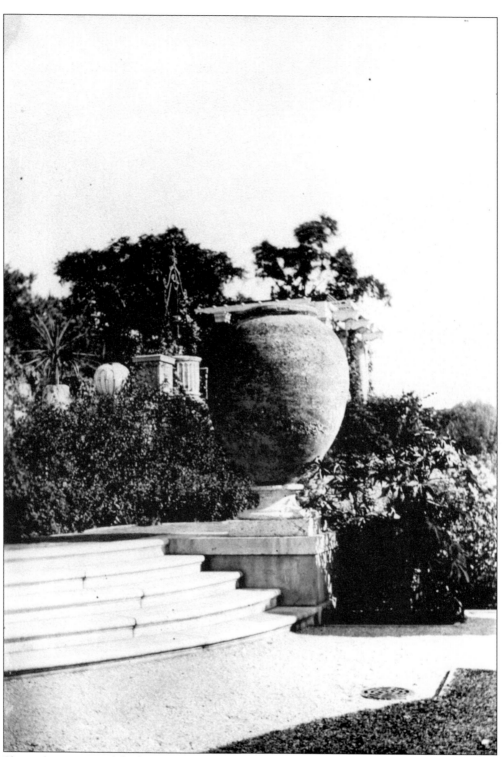

Shown here is one of the large Roman wine or oil jugs appearing in the Italian garden.

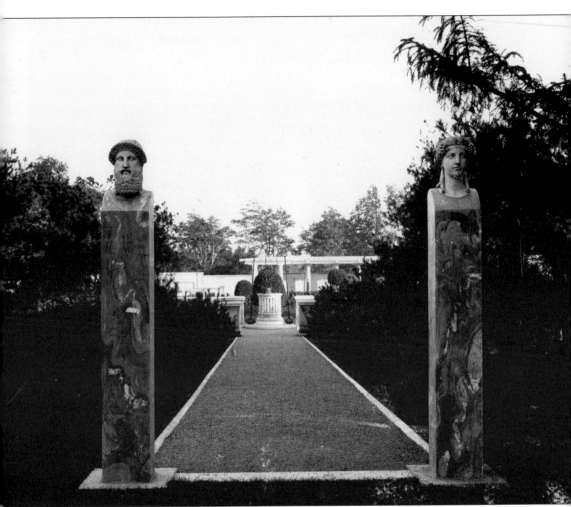

In addition to being a romantic reminder of the Andersons' meeting in Rome, the Italian garden was a sophisticated feature. At the time it was built, the study of Italian culture was fashionable among Boston high society.

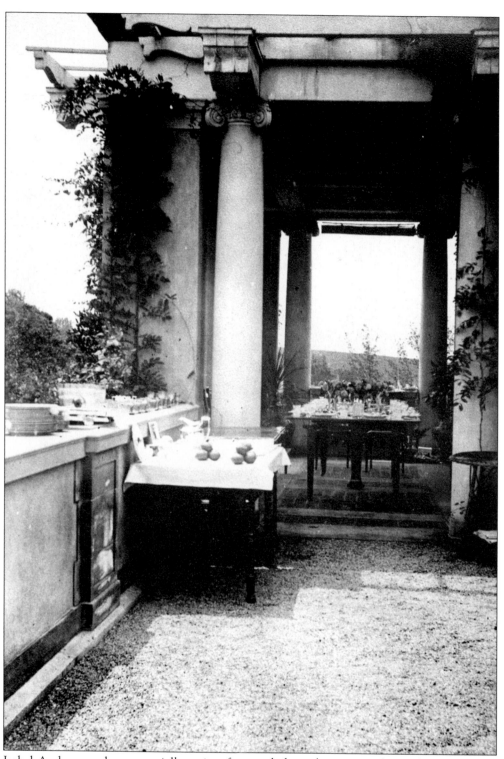

Isabel Anderson, who was socially active, frequently hosted parties in the gardens. Here, the colonnade is set up for outdoor dining.

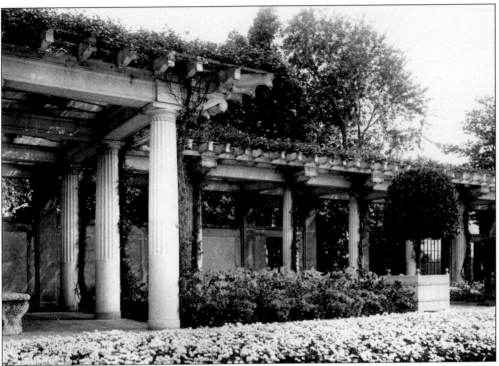

This image shows the elaborate colonnade structure, which still stands today.

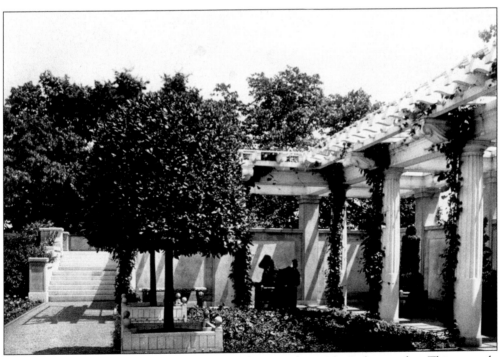

The seated dog was just one of the sculpted hedges populating the Italian garden. This example of topiary hints at the skill employed to keep Weld looking perfect.

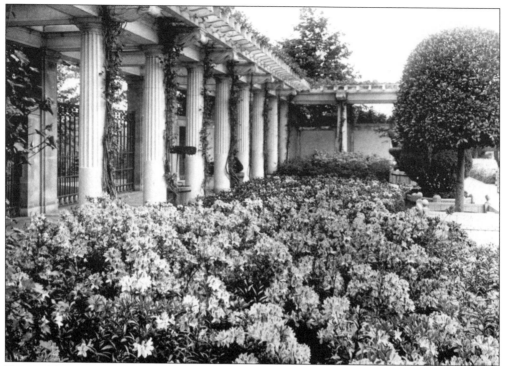

Flowers bloom in the Italian garden.

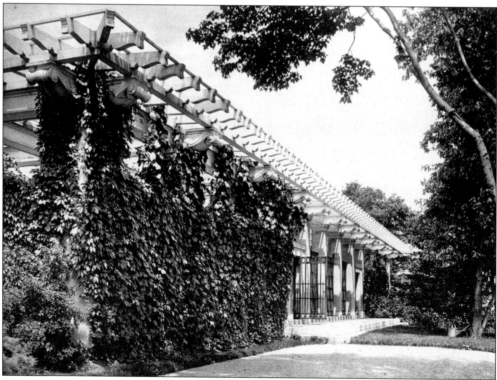

The colonnade trellis appears here.

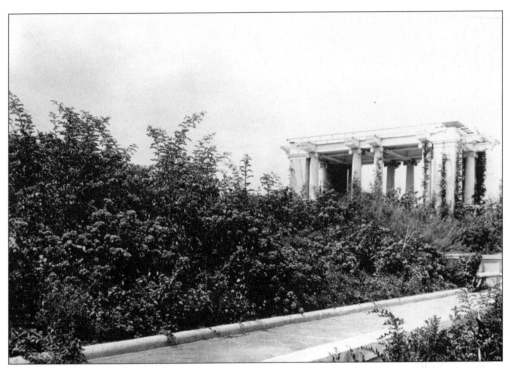

The garden's greenery was elaborate.

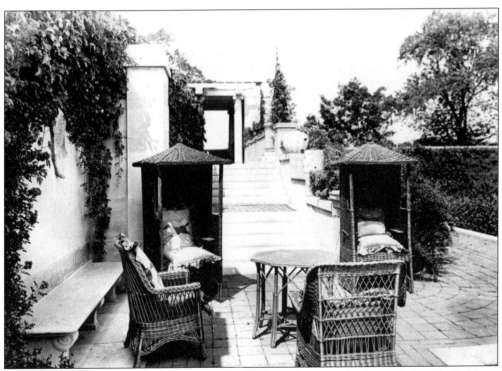

These Asian-style chairs are decorated with pillows bearing the logo of the Black Horse Shipping Lines, Isabel Anderson's family shipping company.

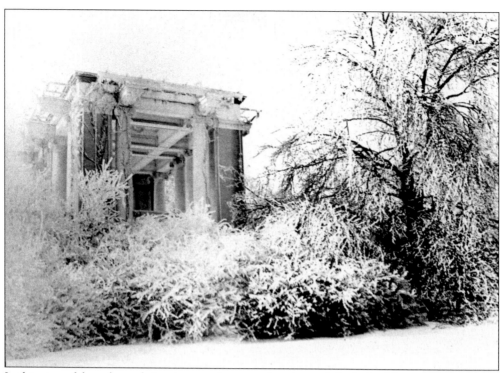

In this view of the colonnade in winter, an icy storm has changed the look of the park dramatically.

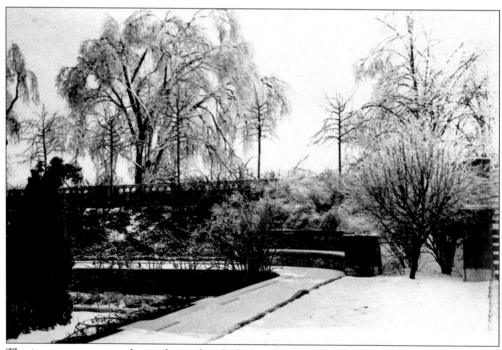

The icy greenery gives the garden a ghostly feel in this wintertime scene.

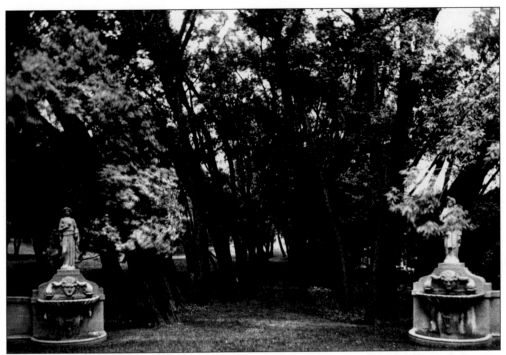

This alley, located at the far end of the park at the corner of Goddard and Avon Streets, included a grouping of trees that remains quite similar today.

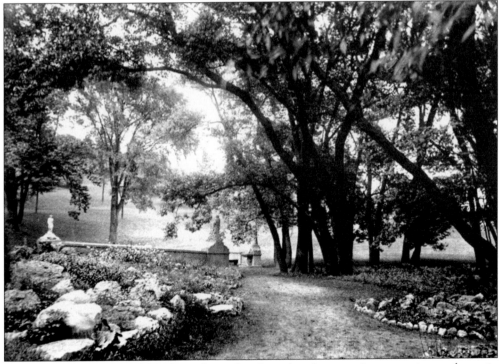

Willow Way was a peaceful little garden, a less formal and more private contrast to the main Italian garden.

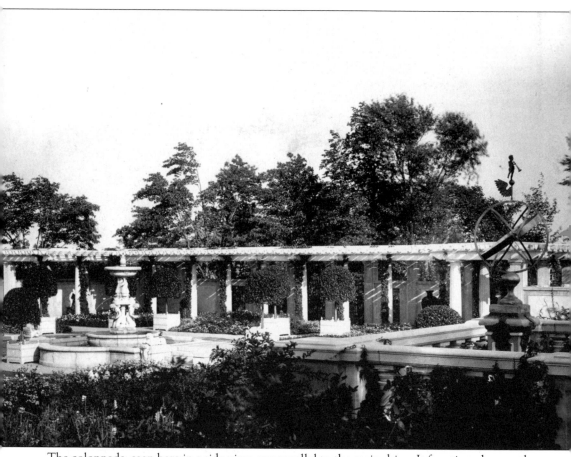

The colonnade, seen here in a side view, ran parallel to the main drive. It functioned as another way of connecting the main house with the Italian garden.

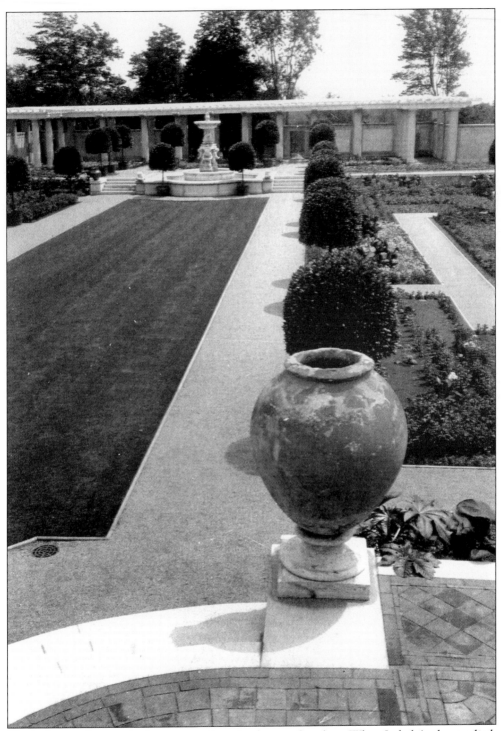

The Italian garden required constant upkeep by dozens of workers. When Isabel Anderson died, there was no staff to look after the property, and the Italian gardens quickly fell into disrepair.

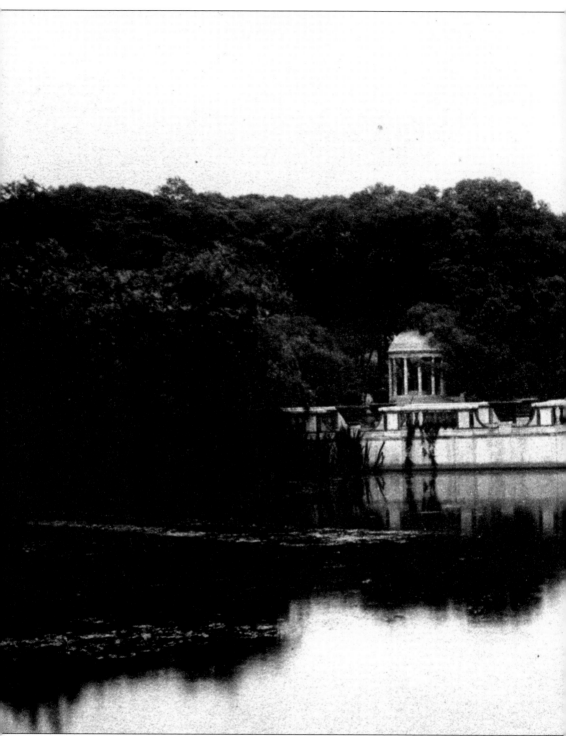

Though not as elaborate as the Italian garden, the water garden is probably the one most associated with the park. This is likely due to the small temple, which still stands today. The water garden perfectly reflects the romantic and idyllic setting the Andersons created for

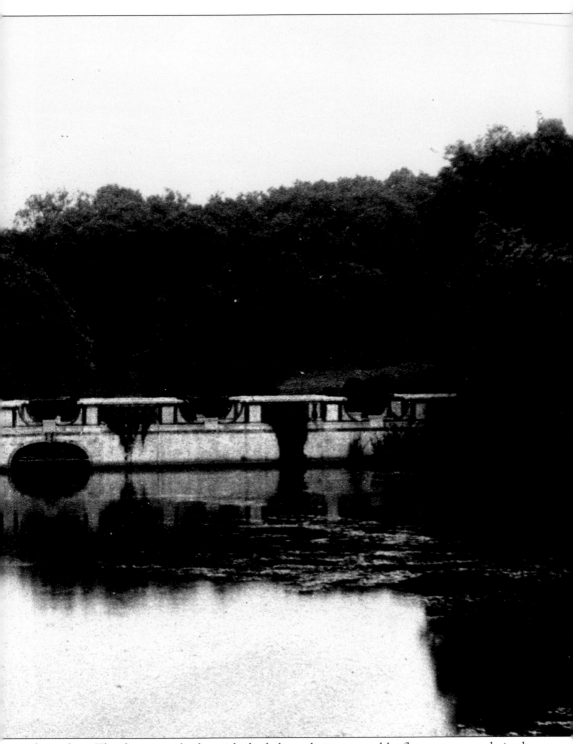

themselves. The decorative bridge with the balustrade interrupted by flower pots was derived from the Isolotto in Florence's Boboli Gardens.

The clearly romantic nature of the water garden reflected the Andersons' sensibilities perfectly.

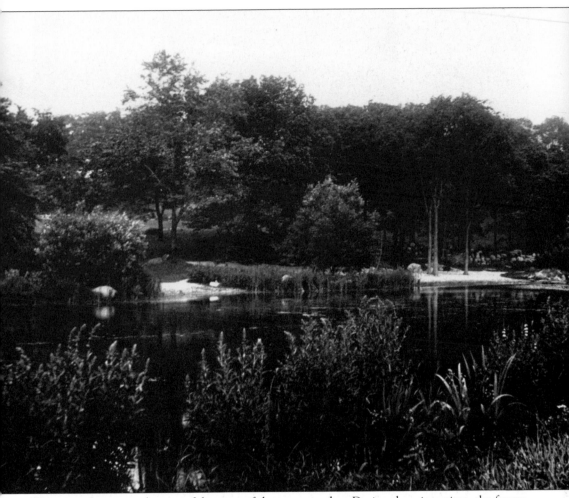

This view showcases the peaceful nature of the water garden. During the wintertime, the frozen garden was used for ice-skating. On these occasions, Isabel entertained skaters with a silver service of hot drinks brought down from the house.

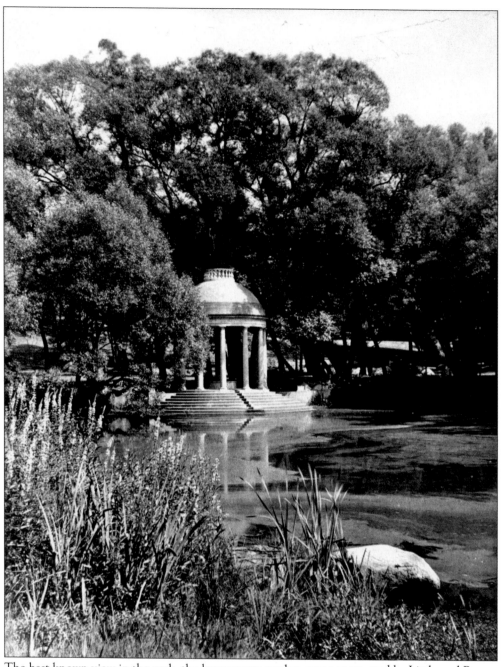

The best known view in the park, the lower water garden, was constructed by Little and Brown in 1910.

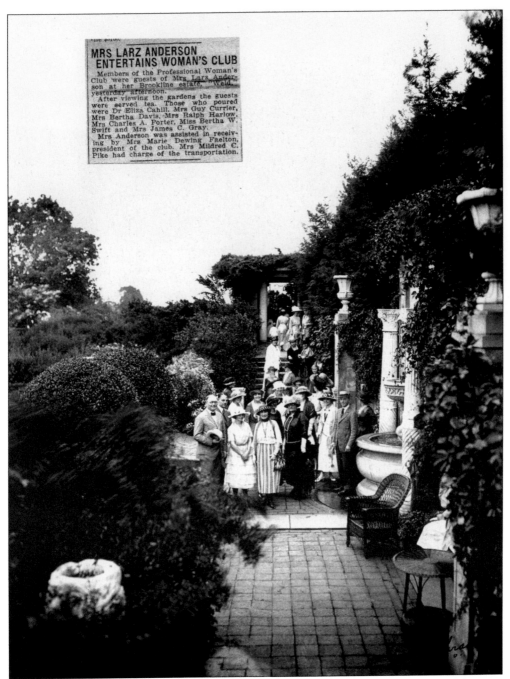

MRS LARZ ANDERSON
ENTERTAINS WOMAN'S CLUB

Members of the Professional Woman's Club were guests of Mrs Larz Anderson at her Brookline estate, "Weld," yesterday afternoon.

After viewing the gardens the guests were served tea. Those who poured were Dr Eliza Cahill, Mrs Guy Currier, Mrs Bertha Davis, Mrs Ralph Harlow, Mrs Charles A. Porter, Miss Bertha W. Swift and Mrs James C. Gray.

Mrs Anderson was assisted in receiving by Mrs Marie Dewing Faelton, president of the club. Mrs Mildred C. Pike had charge of the transportation.

It is no surprise that Weld was used to entertain the local garden club. Offering some of the most spectacular gardens in the area, the estate was a real treat for clubs lucky enough to be invited. Letters indicate that Isabel hosted a number of students studying horticulture over the years.

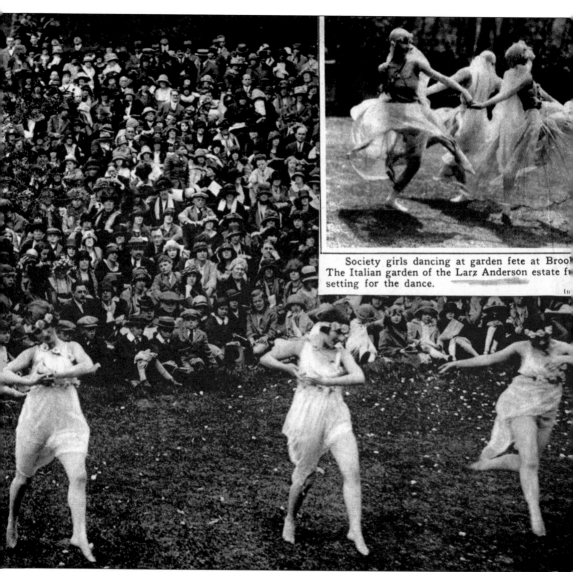

Society girls dancing at garden fete at Broo~
The Italian garden of the Larz Anderson estate f~
setting for the dance.

Isabel Anderson held many theatrical performances at the estate. She wrote several plays, which were performed here, as were more casual dance routines. The park was equipped with its own amphitheater for such purposes. Here, people act in Isabel's fairy operetta *Marina*.

Three

THE SPELL OF JAPAN

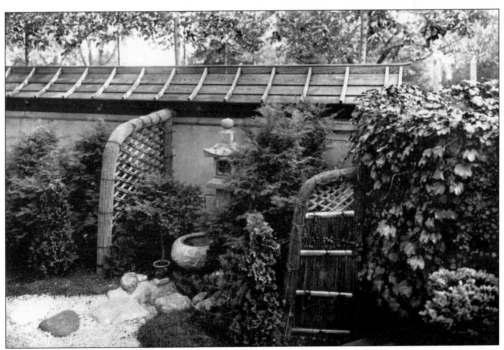

Perhaps the most innovative parts of the Andersons' estate were the Japanese and Chinese gardens. Though not uncommon today, a garden like this was highly unusual at the time. The Andersons spent their honeymoon in Japan. The trip affected them greatly. When they returned, Isabel wrote a popular book called *The Spell of Japan*, and the Japanese garden was built as a reminder.

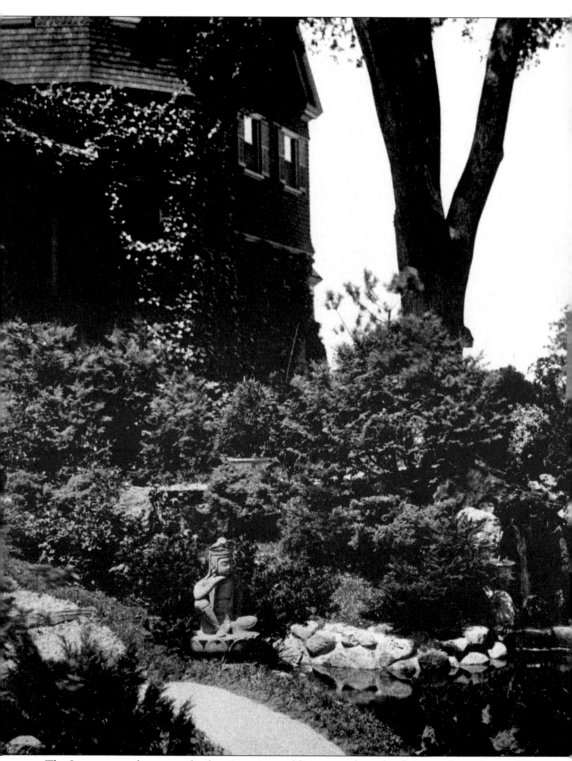

The Japanese garden sported a few American additions, such as the flying eagle sculpture. The eagle standing guard over the garden represented Larz Anderson's connection to the Society of

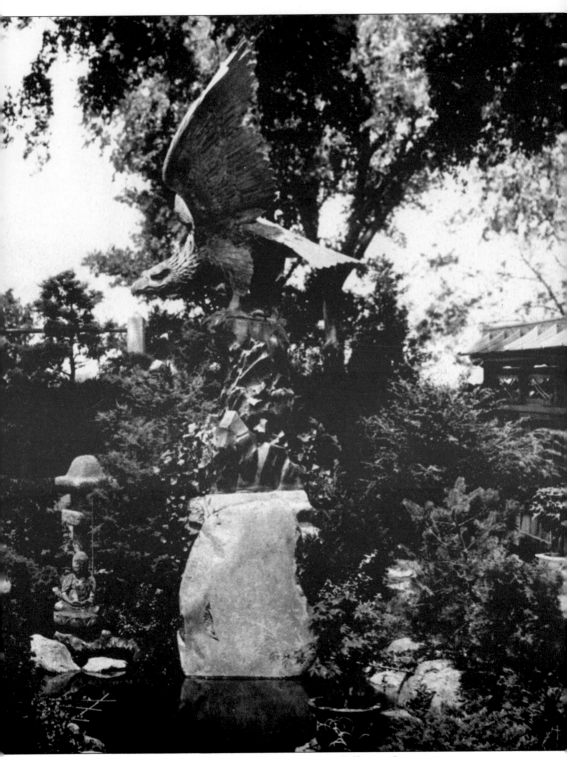

the Cincinnati. The bronze eagle now resides at Boston College, where it is on permanent display in front of Gasson Hall.

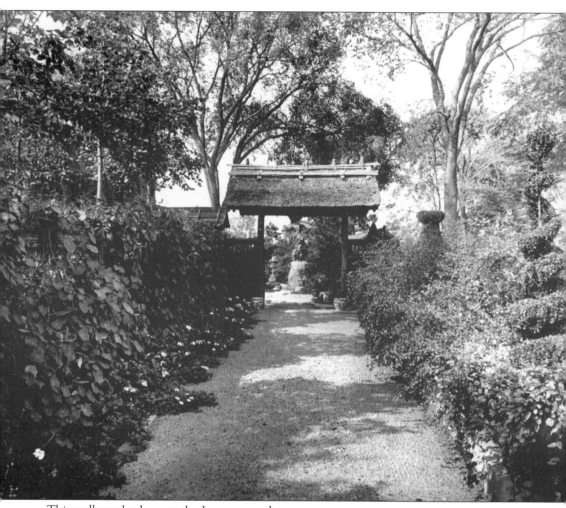

This walkway leads up to the Japanese gardens.

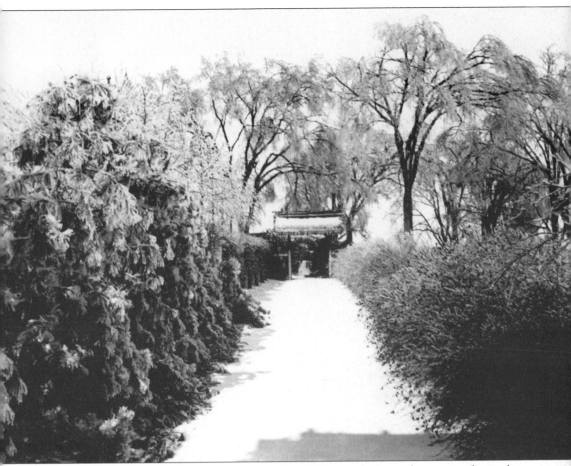

The Andersons employed a Japanese gardener, Onchi San, to design and maintain the garden. There, they were successful in creating a quiet and peaceful place.

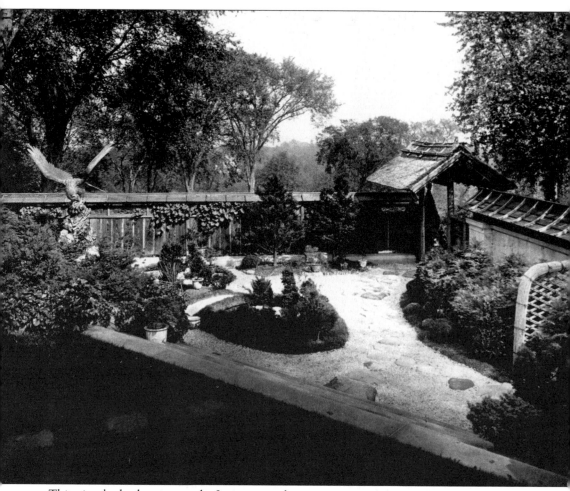

This view looks down upon the Japanese garden.

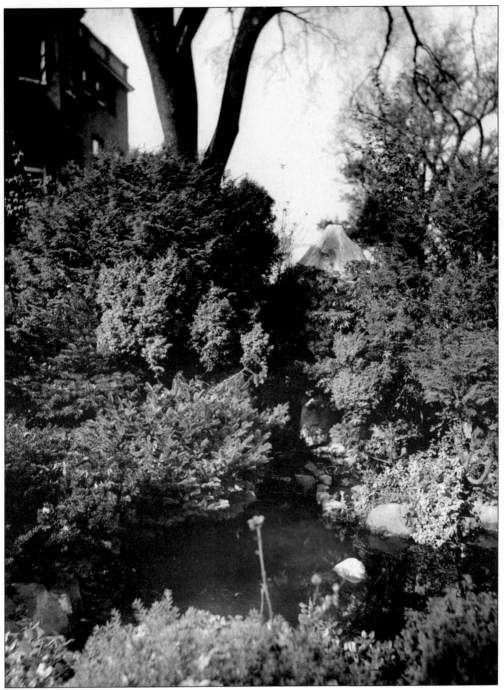

In their Japanese garden, the Andersons created a miniature Mount Fuji.

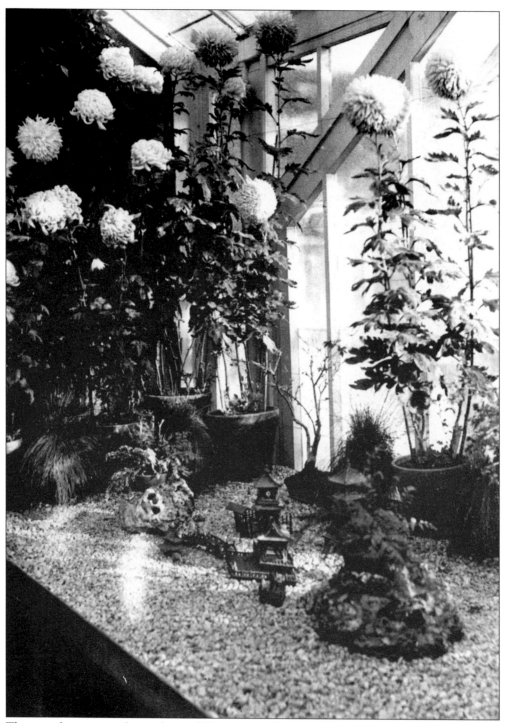

The greenhouses even boasted a small Japanese garden.

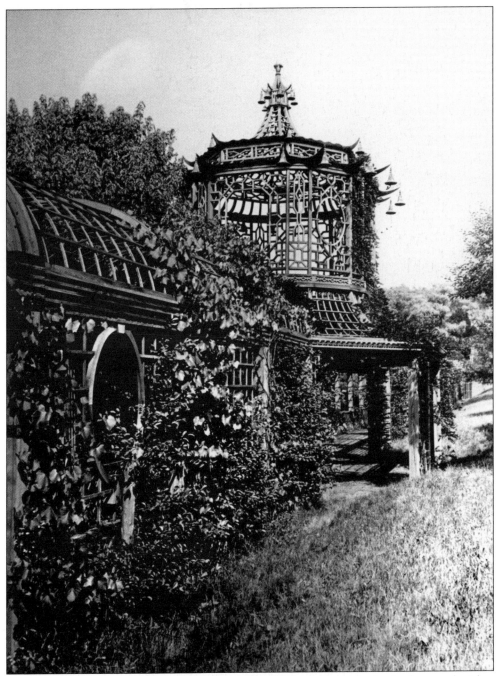

The ambitious Chinese garden had a central pagoda-like tower and a basin decorated with a lion-mask fountain spout and statue. Running 200 feet in either direction were barrel-vaulted wooden pergola.

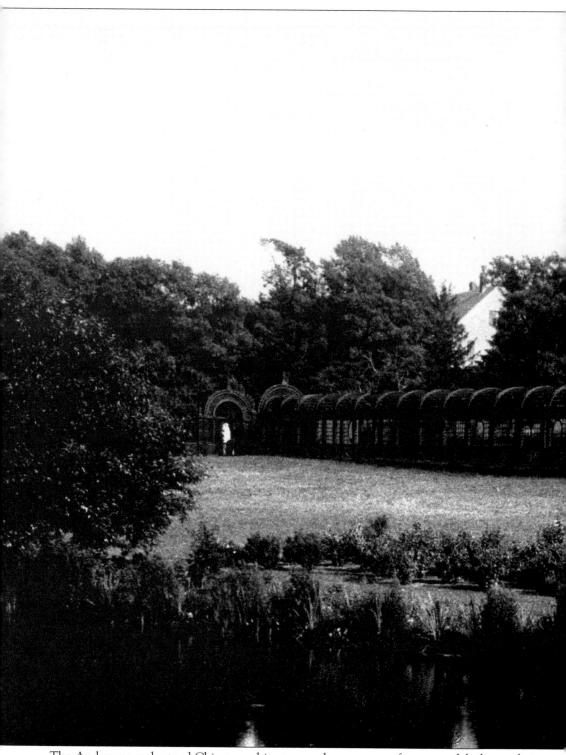

The Andersons understood Chinese architecture and were aware of many models due to their travels. The structure at Weld is said to resemble the latticework at Laken, Belgium.

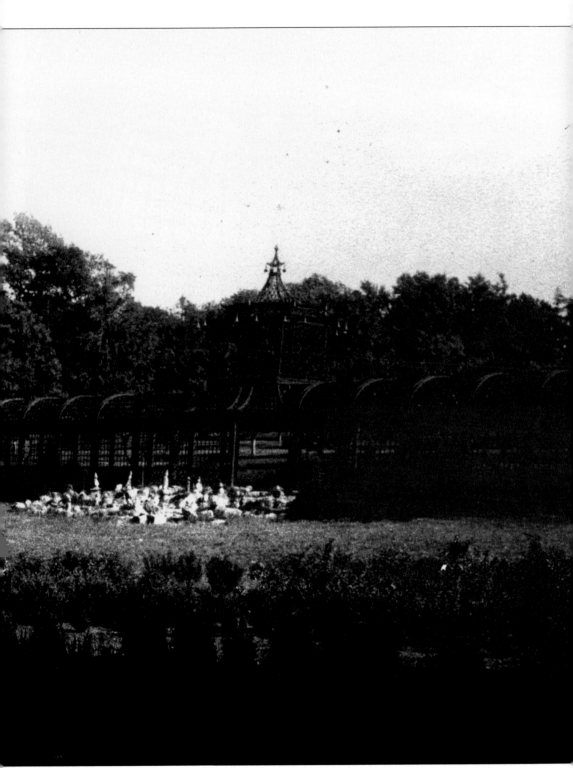

The Andersons would have likely seen this, as Larz served as American ambassador to Belgium.

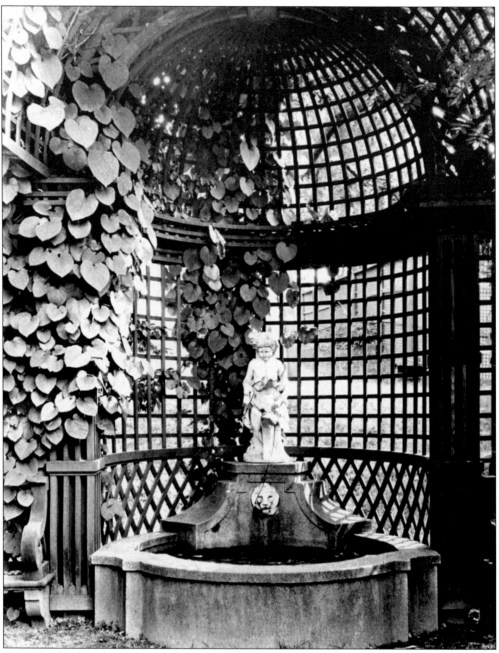

A touch of Italian design amongst the Asian surroundings, a small cherubic fountain sits inside the large Chinese structure.

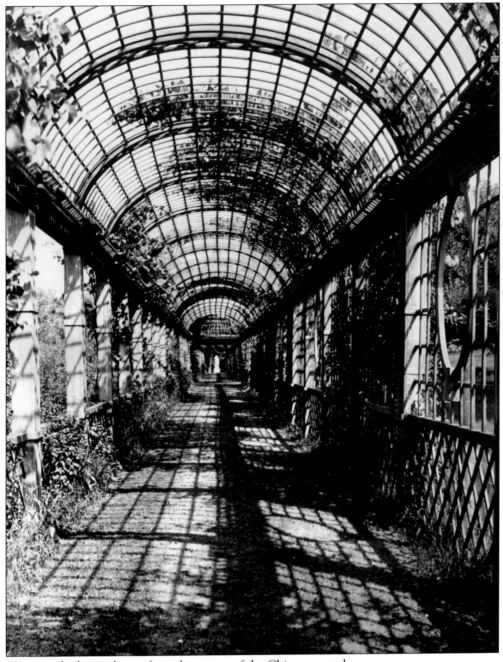

This view looks northwest from the center of the Chinese pergola.

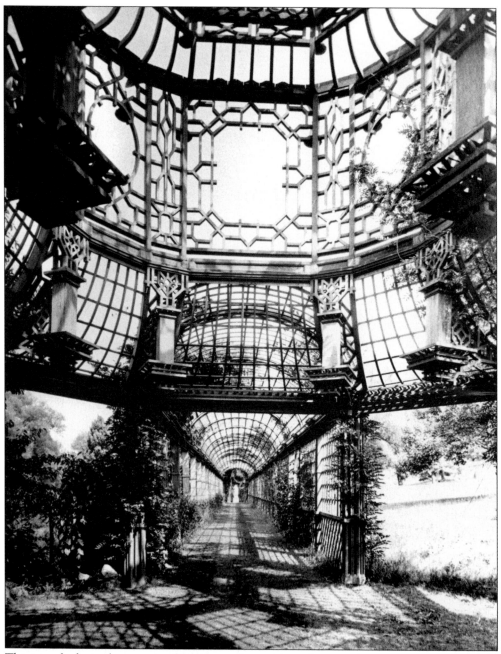

This view looks in the opposite direction as the previous photograph.

Four

A Carriage House Full of Treasures

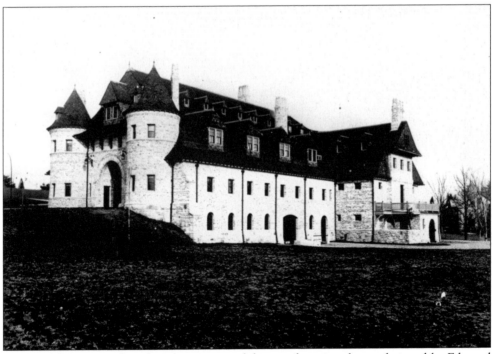

No expense was spared in the construction of the grand carriage house designed by Edmund March Wheelwright. The innovative use of steelwork and beautiful woodwork has made this structure a landmark since it was built.

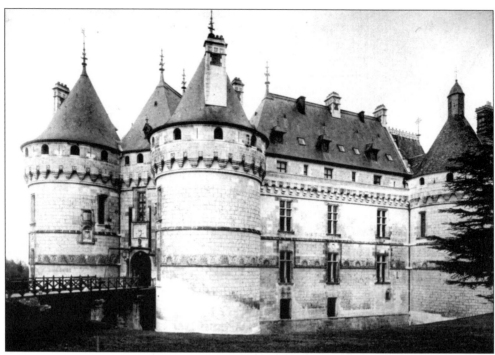

Chateau Chaumont, located in the Loire Valley in France, was the inspiration for the design of the carriage house. This photograph was from Larz Anderson's personal collection.

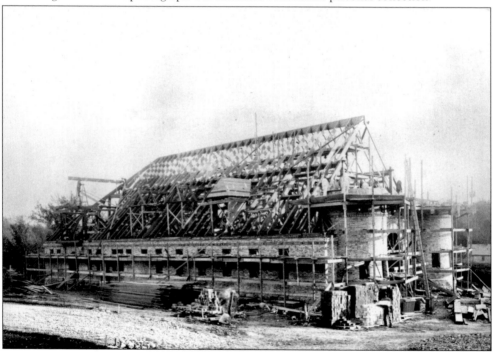

Here, the carriage house is being constructed in 1888. Originally built as Weld Stable, it later evolved to hold an array of vehicles. A marvel of engineering in its day, the carriage house has been a home to the Andersons' cars and carriages for well over a century.

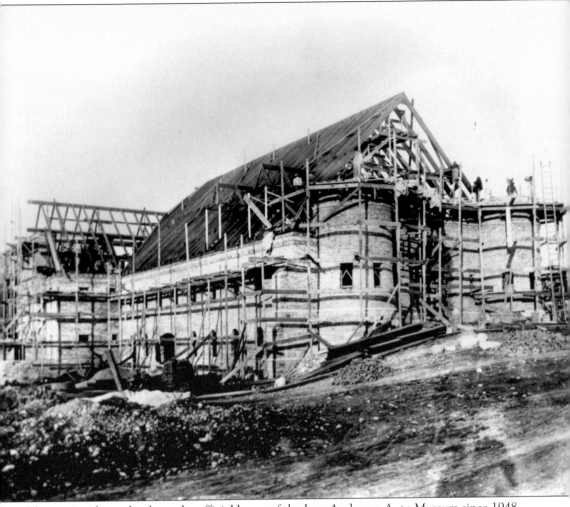

The carriage house has been the official home of the Larz Anderson Auto Museum since 1948. Recognizing the importance of their automobiles, the Andersons placed their collection on view as a private museum in the 1920s.

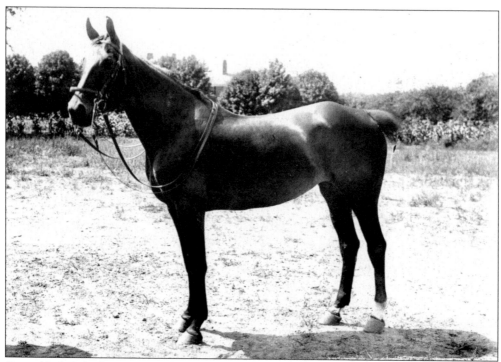

One of Isabel Anderson's prized horses appears here. The Andersons owned countless horses, keeping them in magnificent stalls in the carriage house. As the stables were lined with marble and decorative brick, the animals lived in luxury.

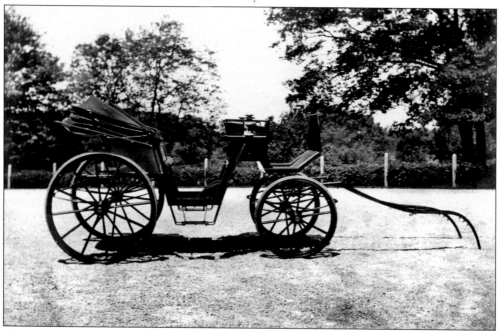

The Andersons also owned many fine carriages, which they used for transportation before acquiring their automobiles, though they continued to purchase and use carriages into the 20th century. This fine Biarritz was built by the Brewster Carriage Company of New York.

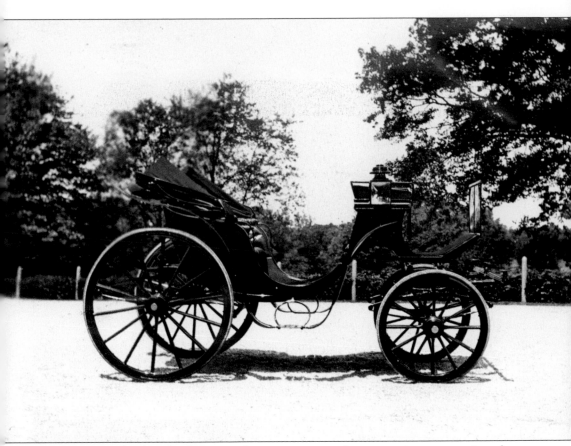

This Victoria, also by the Brewster Company, is an elegant carriage appropriate for a distinguished lady like Isabel Anderson.

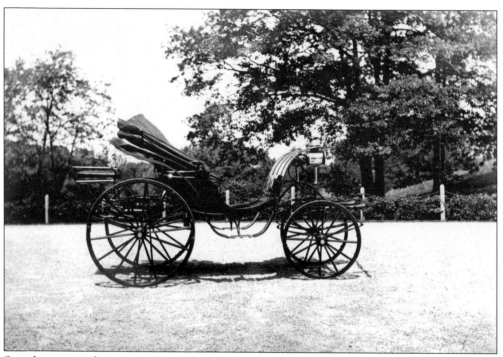

Seen here is another, even more delicate, Victoria carriage.

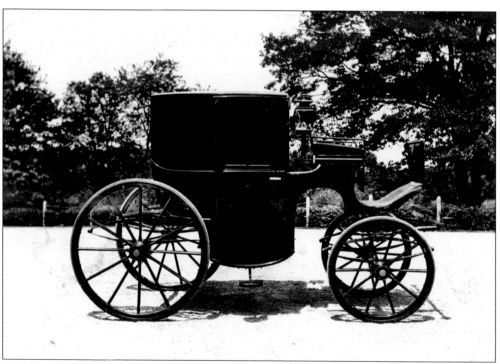

This formal enclosed exposition brougham by Brewster was useful in less-than-ideal weather.

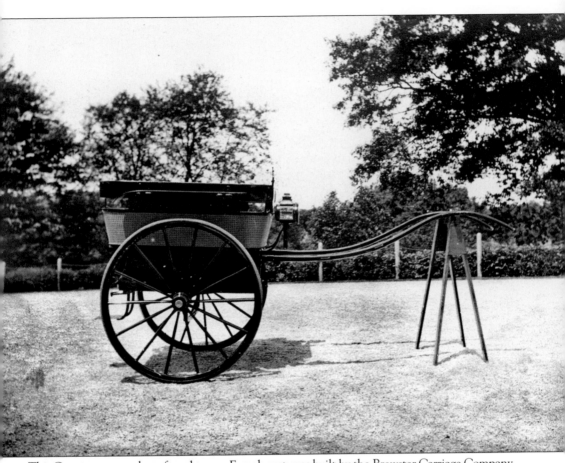

This Governess cart, also referred to as a French cart, was built by the Brewster Carriage Company.

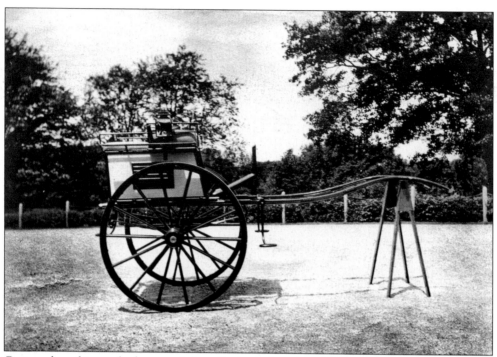

Carts such as this one had a space below the driver for a dog to be transported. They were often used for getting dogs to hunts.

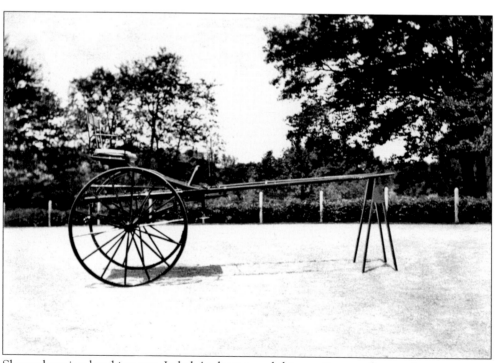

Shown here is a breaking cart. Isabel Anderson used this sporting cart frequently.

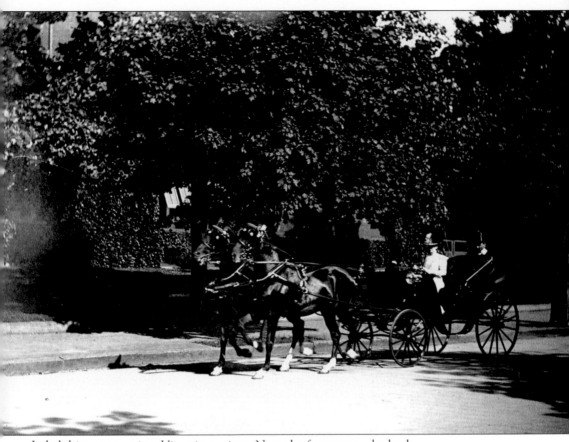

Isabel drives a team in a Victoria carriage. Note the footman at the back.

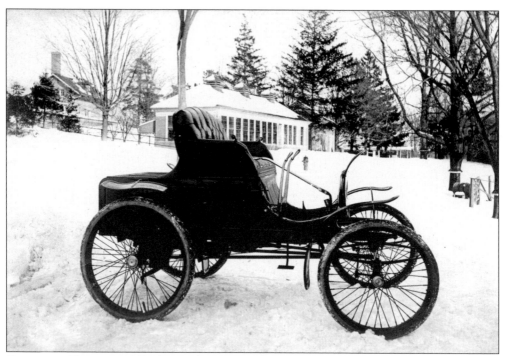

On a trip to France in 1889, the Andersons saw their first motorcar buzzing about the streets of Paris. Immediately taken with the vehicle, they set out to purchase one upon their return home. The first car they bought was an 1899 Winton. This little one-cylinder buggy cemented their fascination with automobiles, and the Andersons would become true motoring pioneers.

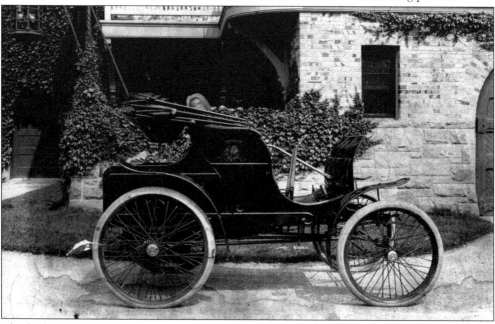

The little Winton was given a name and motto, as were all the cars they purchased after it. "Pioneer" was its name and "*ça ira*" (French for "It will go") was its motto. The Andersons bought a new car every year, keeping almost all of them.

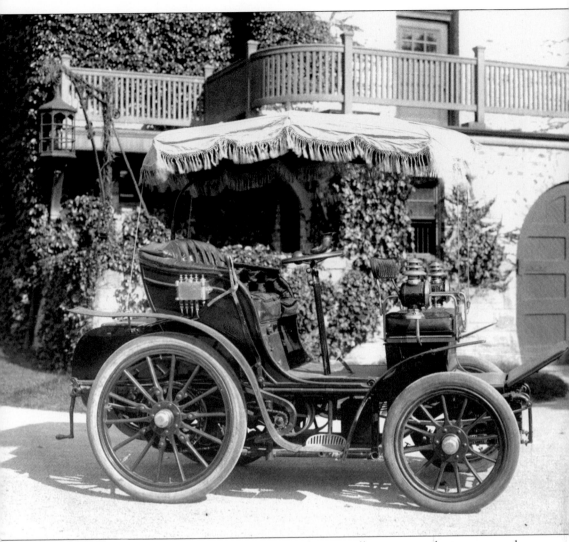

This portrait depicts the Andersons' Rochet-Schneider. As well as giving each one a name, the couple took photographic portraits of all their automobiles. These images were hung in the carriage house.

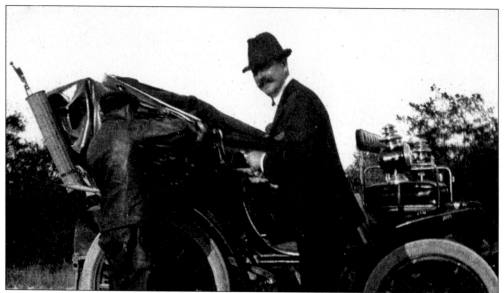

Larz Anderson is pictured with his second car, the 1900 Rochet-Schneider. Larz and his chauffeur have stopped to fill up the oil reservoir, a common task on a car of this period.

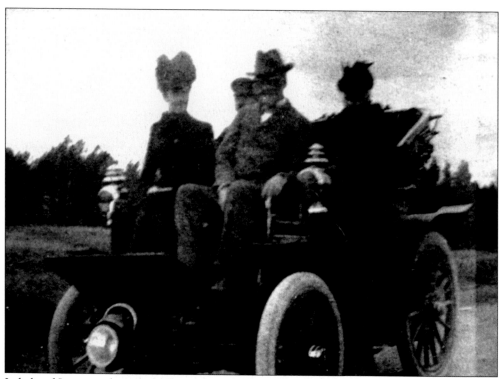

Isabel and Larz, seen here in the front seat, are out enjoying a day of motoring. In the back seat are the chauffeur and an unidentified guest. In goggles, Larz seems to be enjoying himself immensely.

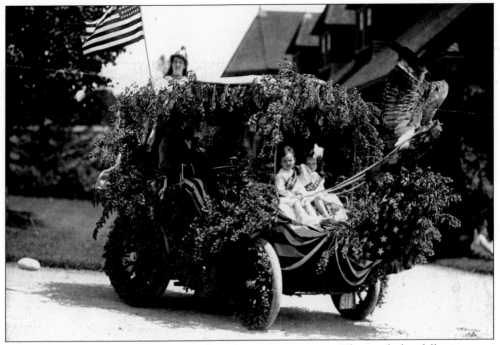

The motorcars were used for more then just transportation. This and the following two photographs show the Rochet-Schneider dressed up for Independence Day, covered in flowers and flags and bearing a stuffed eagle flying at the front.

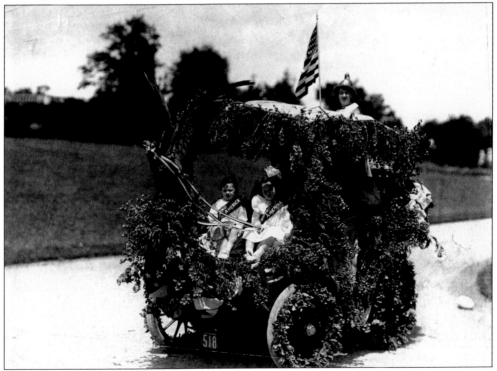

The Andersons' efforts were rewarded with a first-prize cup.

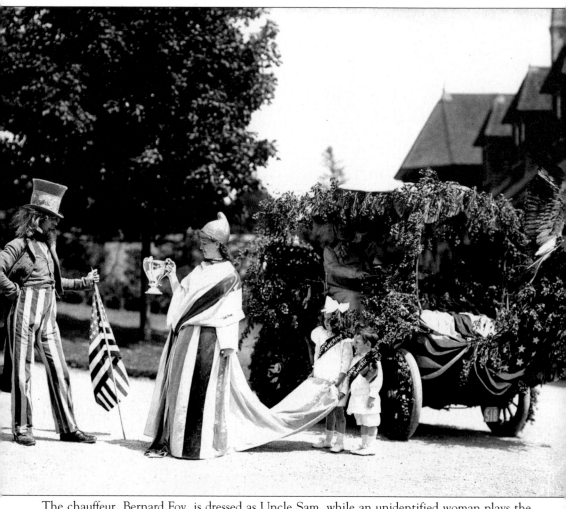

The chauffeur, Bernard Foy, is dressed as Uncle Sam, while an unidentified woman plays the part of Liberty. The two children represent young America.

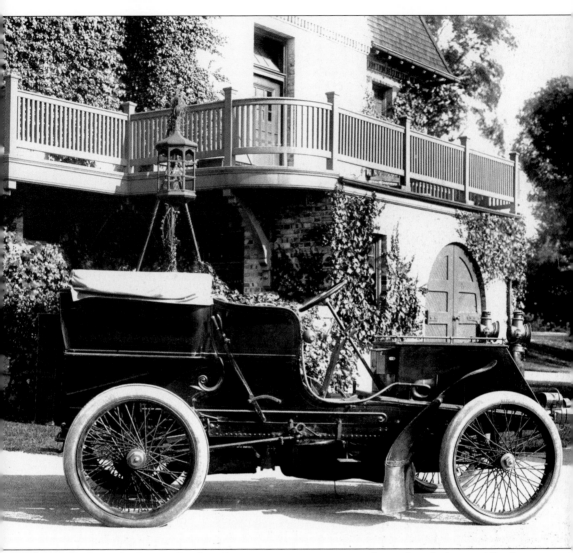

In 1901, Larz Anderson developed an interest in racing and purchased the world's first production race car: the Winton 40-horsepower. This was the most potent—and perhaps most finicky—machine that could be bought at the time.

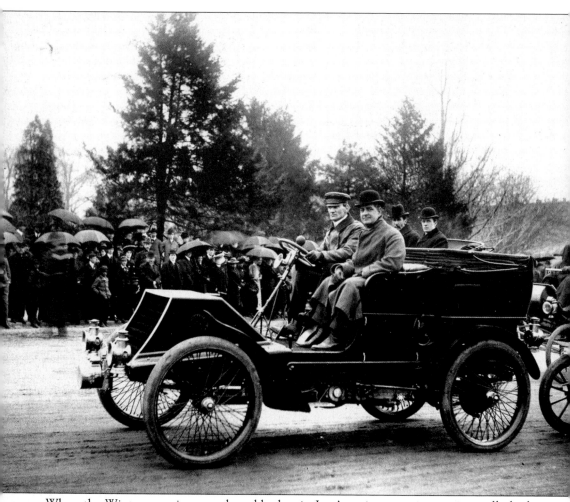

When the Winton ran, it was unbeatable, but in Larz's racing experiences, it usually broke down. A well-publicized race took place at the Brookline Country Club. Larz shot out into the lead and was several laps ahead of his competitor when the machine quit and failed to restart.

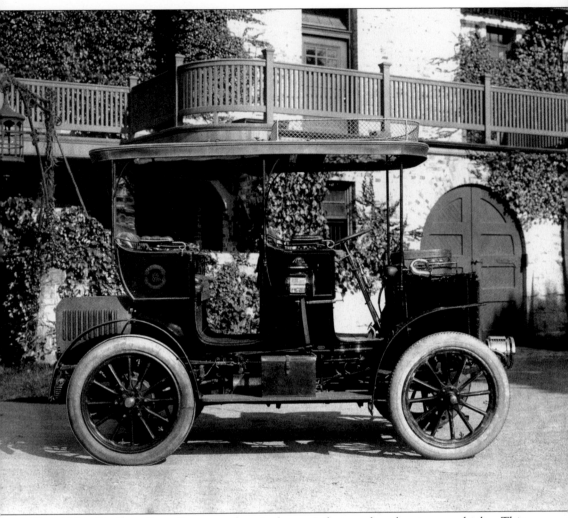

The 1903 Gardner Serpollet was the Andersons' first and only steam vehicle. This French-made machine, powerful and sophisticated, was years ahead of the locally built Stanley Steamer. The Andersons designed it with two interchangeable bodies by Kellner of Paris. There was an open summer body (seen here) and an enclosed winter body. The Andersons used this car when traveling to their vacation home in New Hampshire.

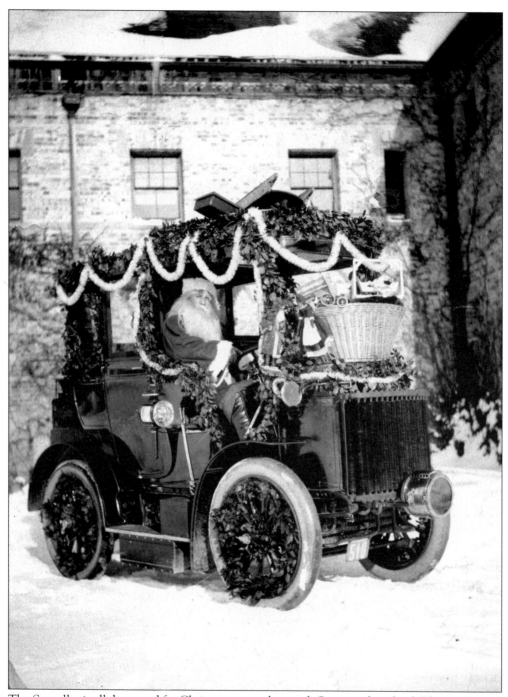

The Serpollet is all decorated for Christmas, complete with Santa at the wheel. The Andersons often hosted children from the Perkins School for the Blind in Newton. Here, the Serpollet is filled with gifts for the children.

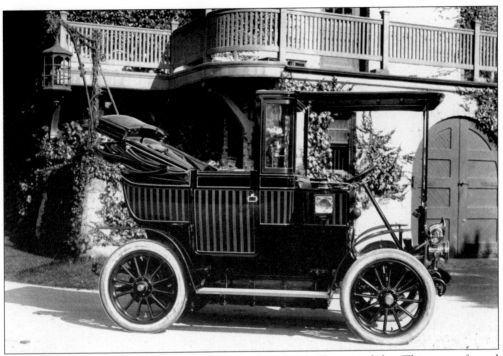

The Anderson's first electric vehicle was this 1905 Electromobile. This very formal English-built automobile was named "*Port Bonheur*," or "Bringer of Happiness." The French motto is "*ça va sans dire*," or "It goes without saying," a play on the silent operation of the electric car.

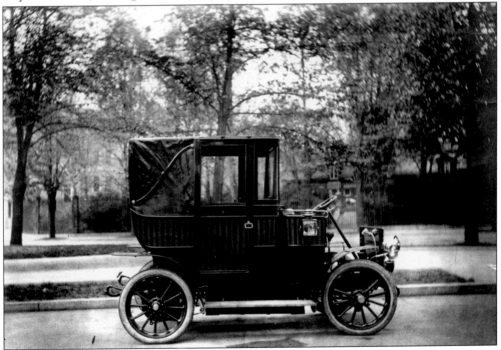

The Andersons used this car for a number of years, but took it off the road because children were throwing stones at it, undoubtedly due to its unusual appearance.

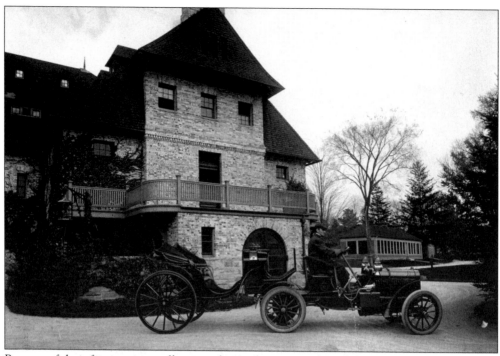

Because of their fine carriage collection, the Andersons purchased this Walter tractor. The odd vehicle was designed to pull carriages in place of horses.

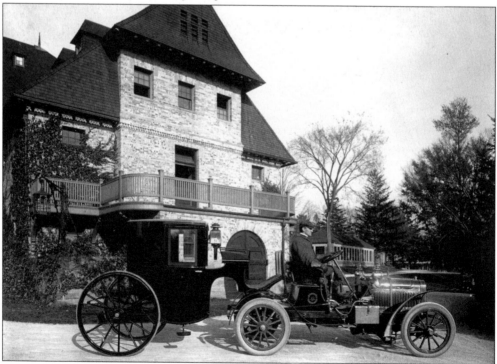

Though a fine-quality vehicle, the Walter tractor became unfashionable very quickly, becoming one of the few vehicles ever disposed of by the Andersons.

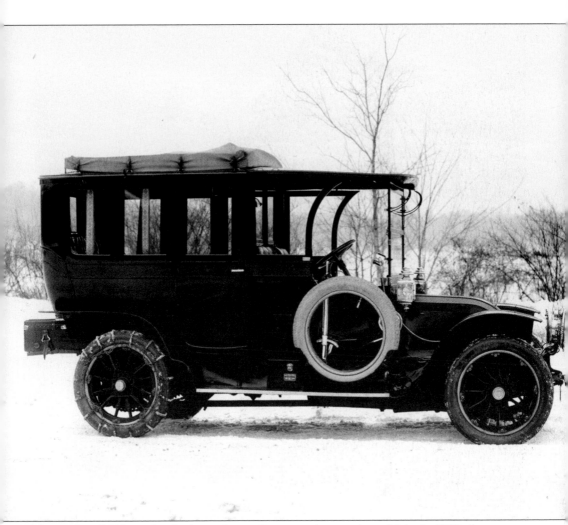

The mighty CGV was the Andersons' most famous and expensive vehicle. In 1907, they spent approximately $23,000 to build it. It is equipped with every comfort of home, including folding beds, bookshelves, a sink, and a toilet.

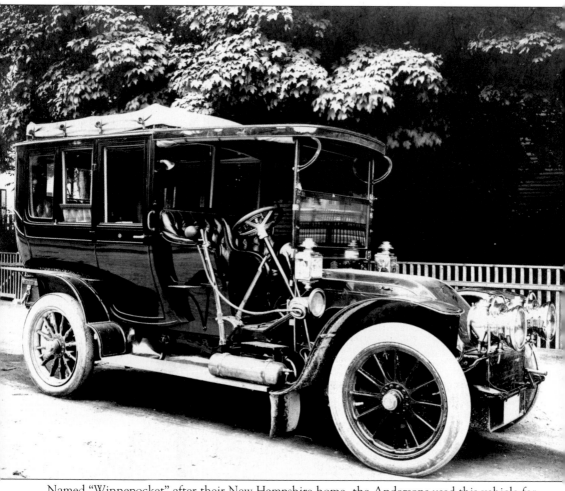

Named "Winnepocket" after their New Hampshire home, the Andersons used this vehicle for long-distance touring. Built on a massive 90-horsepower CGV chassis, it is a magnificent vehicle that is equipped to go anywhere.

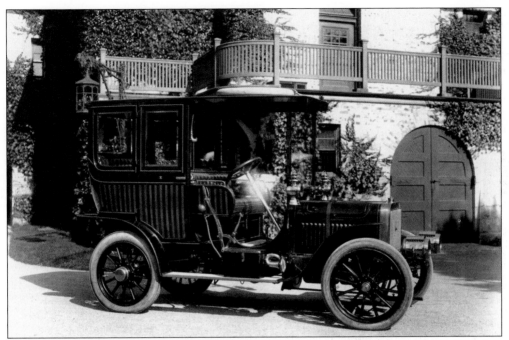

The Andersons' 1907 Walter, like the Walter tractor, is one of the few early vehicles that they parted with; little is known about why or where it went. It was likely given away, perhaps to a staff member.

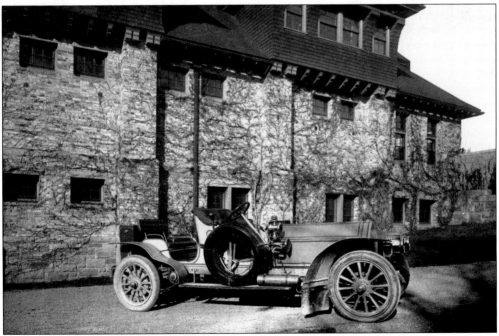

Larz Anderson's sports car was his 1907 Fiat, named "*Il Conquistador*" and given the motto "*no Hill* [sic] *me Pavet*," meaning "no hill can stop me." (Hills were a serious challenge to less-powerful early cars.) This 90-horsepower monster was one of the greatest high-performance automobiles in its day.

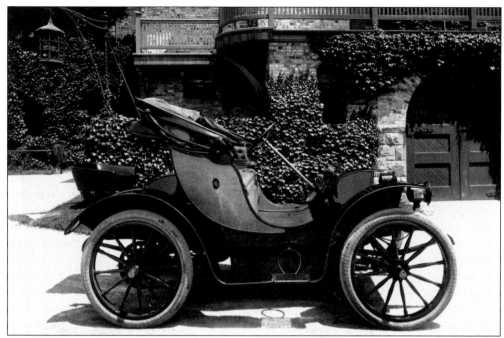

Isabel Anderson's favorite car was this little 1908 Bailey Electric. This elegant carriage-like vehicle was silent to run and required no difficulty in starting. It was the perfect car for short trips into town. Despite its small size, it still had a footman seat on the back.

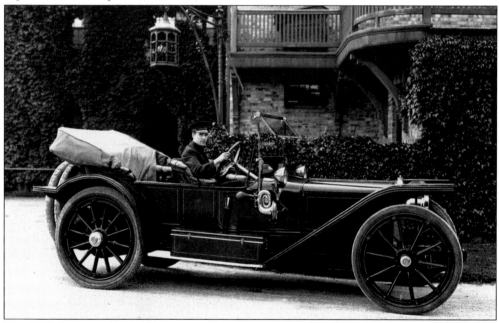

The 1908 American Underslung was named "Captain Ginger" after a children's book written by Isabel. It was a magnificent car with huge wheels and an underslung chassis. Isabel agreed to let her nephew, famed sportsman Briggs Cunningham, take the car in order to restore it. Briggs never returned the car, and it remains the most important automobile outside of the intact original collection. The car still exists today, and has been in a number of public and private collections.

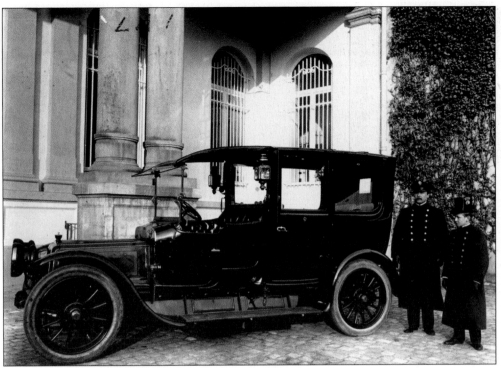

A pair of well-dressed chauffeurs attend the Panhard. A formal town car like this one was used primarily for short social trips to parties or to the symphony.

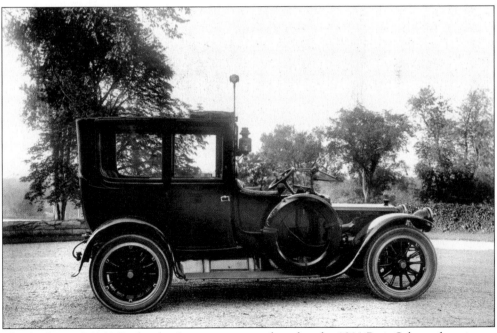

The Andersons' 1911 Panhard et Levassor was purchased at the 1911 Paris Salon, where it was a featured show car. A beautiful vehicle, it was used in contemporary advertising for the coach builder Van Den Plas.

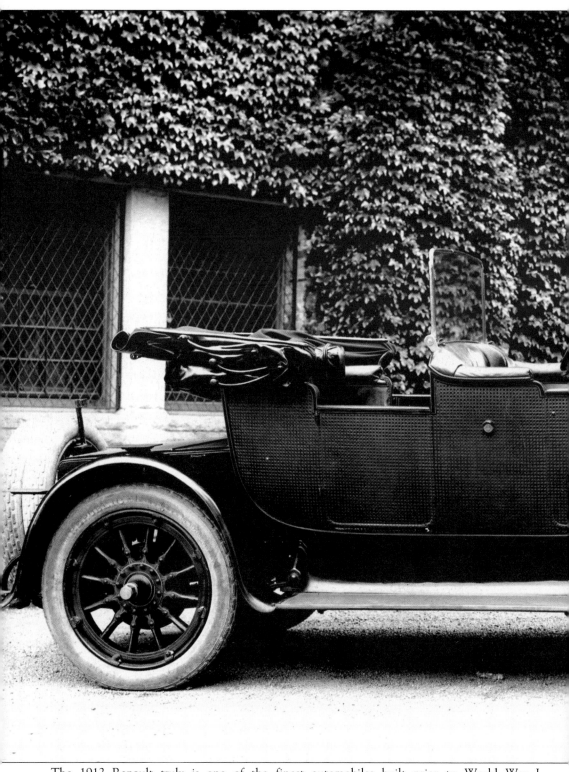

The 1912 Renault truly is one of the finest automobiles built prior to World War I.

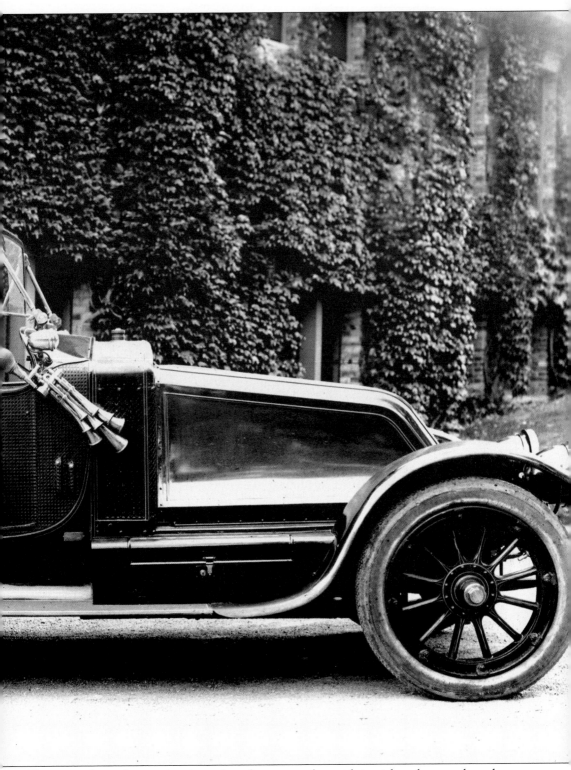

This image shows the car when it was brand new, complete with its eight-tube testophone horn.

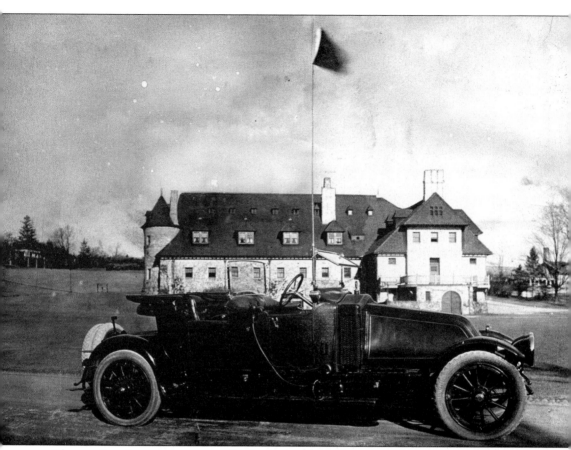

The carriage house appears in the background in this image of the 1912 Renault. The Andersons were fond enough of this vehicle to keep it on the road until 1930. Note the Black Horse Shipping Lines flag mounted on a fishing pole.

After 1915, the Andersons became a bit more conservative in their automotive purchases. This 1916 Packard Twin Six limousine is a fine automobile, but not nearly as flamboyant as many of the couple's earlier cars. The car's body was built by Brewster, the same company that constructed the majority of the Andersons' carriages.

The 1926 Lincoln limousine was bodied in Brookline by George McNear. A fine vehicle in its day, it is much more practical than beautiful.

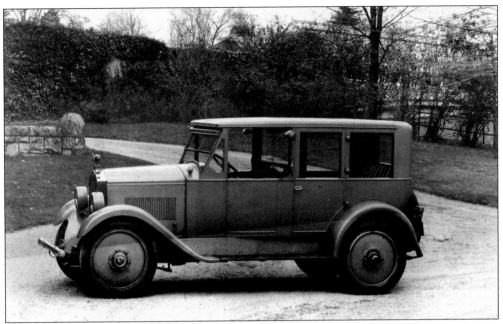

Most of the Andersons' utilitarian vehicles were sold off except for this little 1926 Luxor. Luxors were taxicabs built in Framingham. The Andersons were the only individuals to purchase a Luxor for personal use. They named it, and most of their other work vehicles, "Goliath."

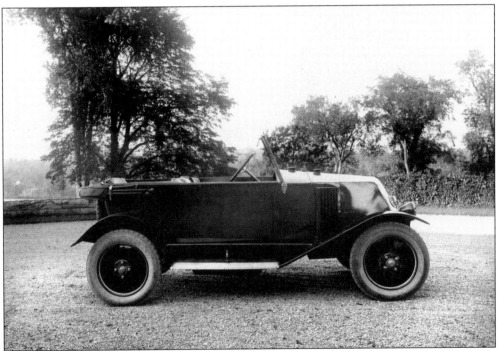

The smallest of all the cars in the Anderson collection, this 1924 Renault is the true baby of the bunch. It was purchased by Larz as a convenient way of getting into town without having to start up the bigger cars.

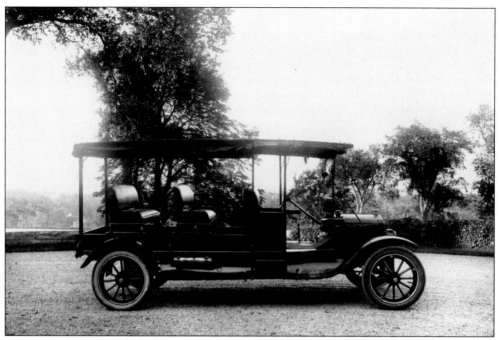

The Andersons purchased a number of utilitarian vehicles, such as this 1916 Model T truck. With the large number of staff at the estate, the couple needed vehicles like these to transport workers. This wooden-bodied Model T has three rows of seats.

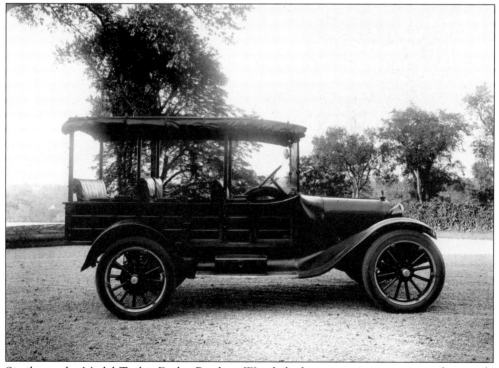

Similar to the Model T, this Dodge Brothers Woody had extra seating capacity and a strictly utilitarian function.

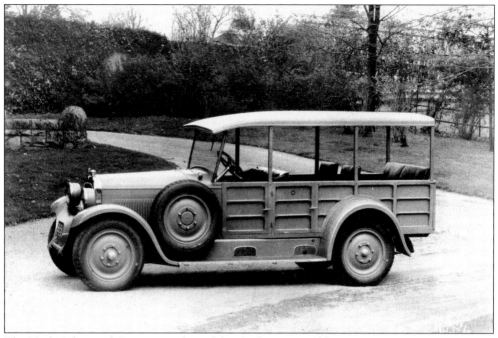

The Nash Advanced Six was another of the Andersons' workhorses.

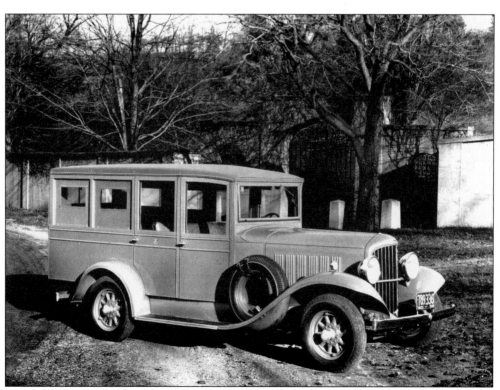

The REO Flying Cloud wagon is parked in front of the large entrance doors to the park. These doors were located at the corner of Newton Street and Goddard Avenue.

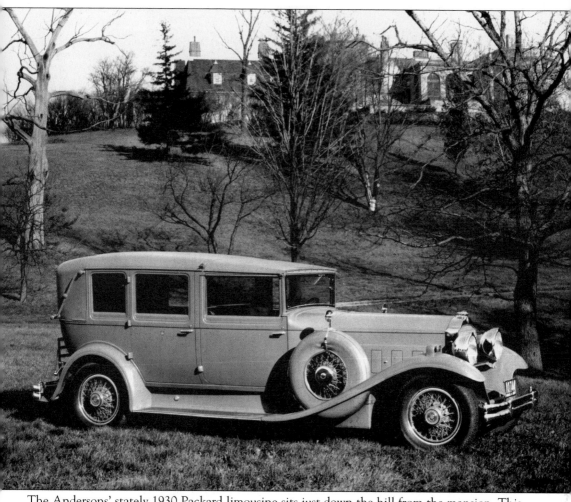

The Andersons' stately 1930 Packard limousine sits just down the hill from the mansion. This photograph reveals a seldom-seen view of the house.

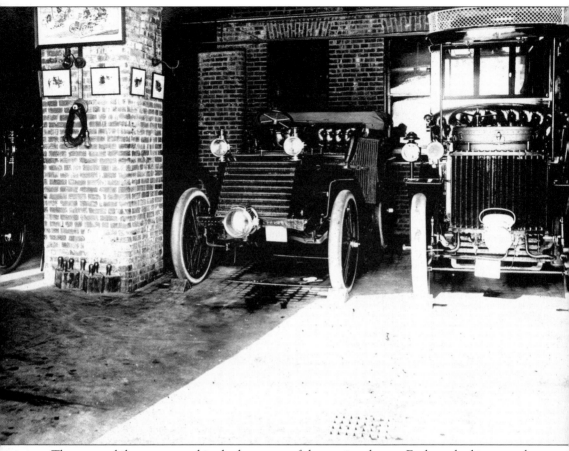

The automobiles were stored in the basement of the carriage house. Each car had its own place and was kept spotless. The room was decorated with very early French automotive art.

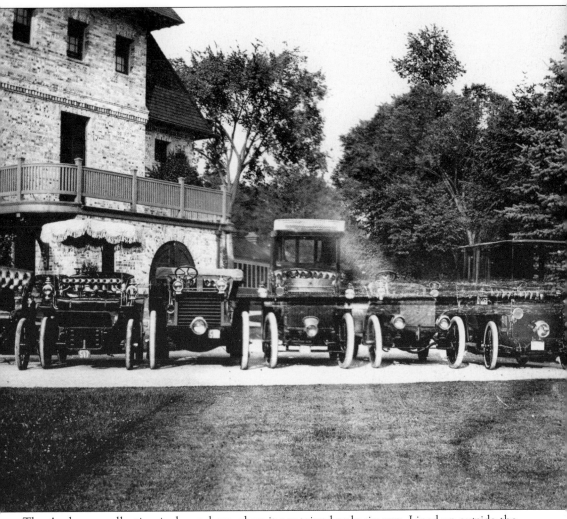

The Anderson collection is shown here when it contained only six cars. Lined up outside the carriage house garage, these pioneers are, from left to right, the 1899 Winton, 1900 Rochet-Schneider, 1901 Winton, 1903 Gardner Serpollet, 1904 Walter, and 1905 Electromobile.

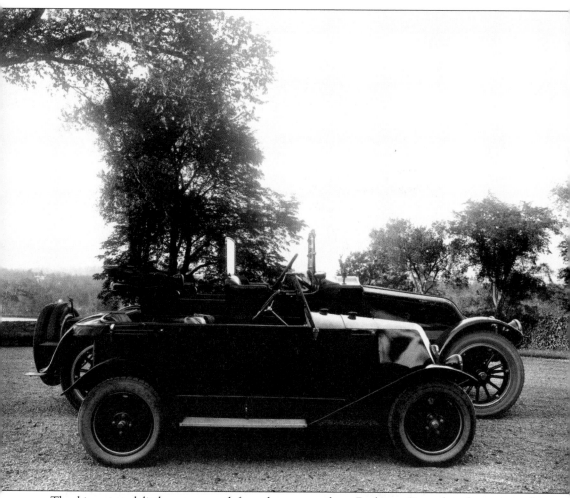

The biggest and littlest are posed for a humorous shot. Both are Renaults; the one in the foreground is from 1924, and the one in the background is from 1912. This photograph was taken near the house, looking away from Boston.

Five

THE HOUSE
ON THE HILL

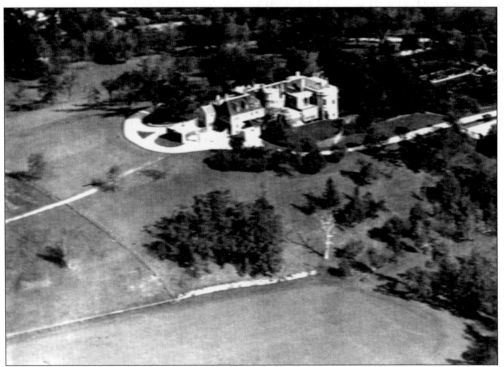

A grand estate like Weld deserved an equally grand home. The Andersons built themselves quite a palace, which reflected their distinctive tastes as much as the rest of the property did.

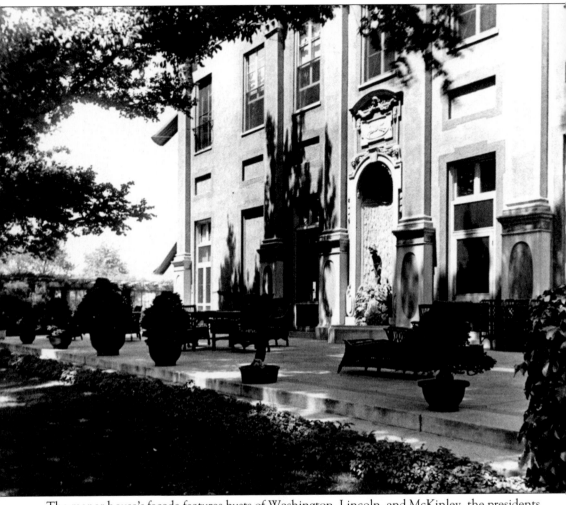

The manor house's façade features busts of Washington, Lincoln, and McKinley, the presidents under whom Anderson men served in the military. Isabel explains in *Under the Black Horse Flag*:

> By his own service, Larz became an original member of the Military Order of the Spanish War, while he inherited from his father the membership in the Military Order of the Loyal legion, of which his father had been an original member, and from his great-grandfather the membership of the Society of the Cincinnati, of which his ancestor had been an original member. This is rather unusual, showing repeated military service in direct descent in the country's great wars, the Revolutionary, the Civil, and the Spanish.

Larz included a photograph of the busts, along with his explanation, in a scrapbook documenting the development of the estate.

The statue on the house's façade is from the Palace of the Beaux Arts in San Francisco. Above it is a carved relief of the Black Horse Shipping Lines flag.

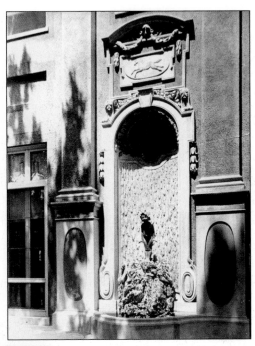

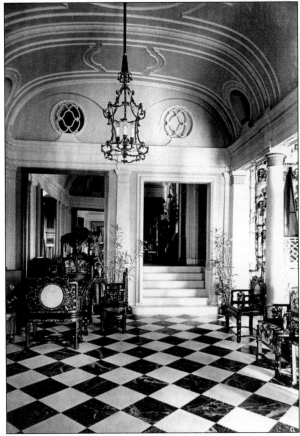

With its checkerboard marble-tiled floors and opulent decoration, the grand foyer is quite a dramatic entryway.

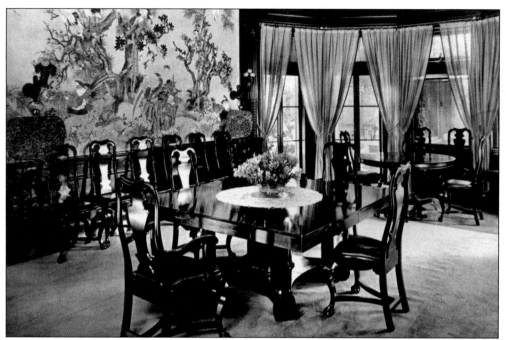

As evidenced by this dining room papered with an elaborate Asian motif, the Andersons were able to successfully integrate different styles into the home.

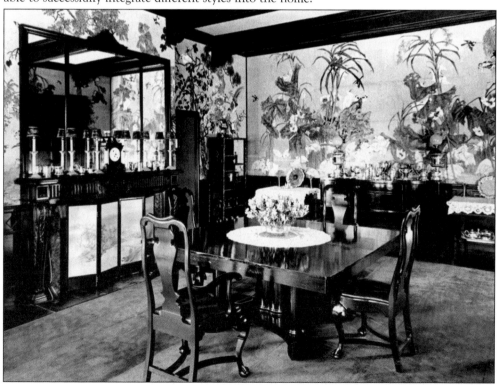

These dining rooms hosted a variety of individuals over the years, from presidents to kings. Weld was the only private home visited by the king of Belgium on his tour of Boston.

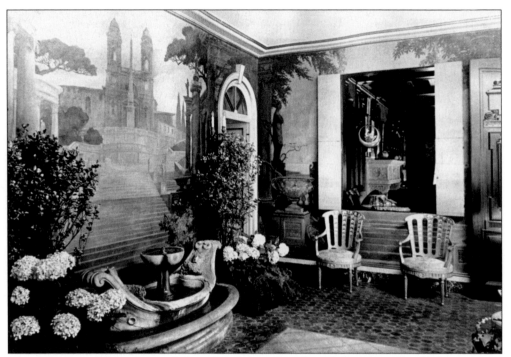

This room has a Romanesque feel, with its painted walls and fountain. The Andersons were interested in bringing the experience of their gardens into their home.

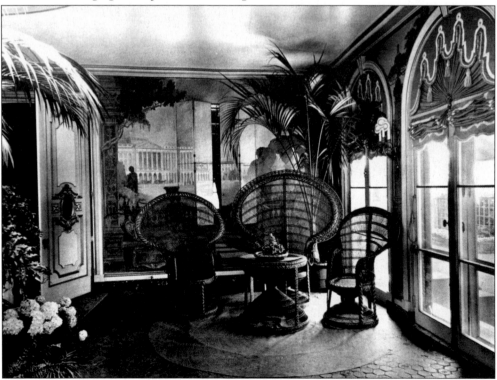

This view of the same room shows the dramatic wicker chairs and palms.

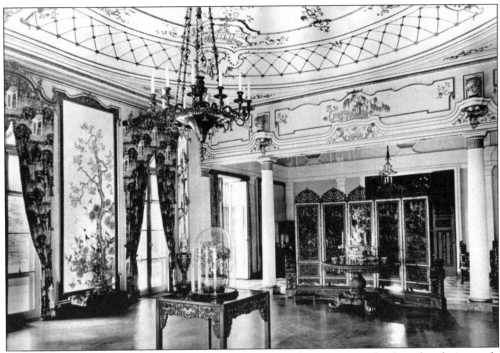

Again, an interesting integration of Western and Asian styling occurs in the formal parlor's motifs.

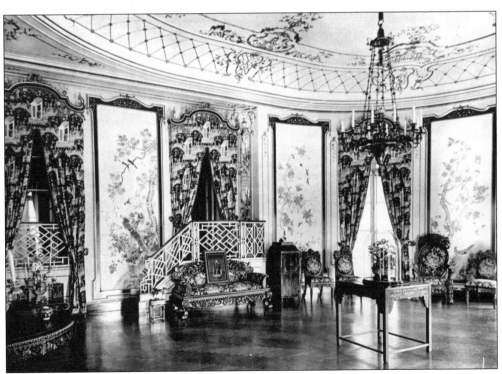

This photograph reveals the size and adornment of the formal parlor. This extensive decoration was in style when the home was built.

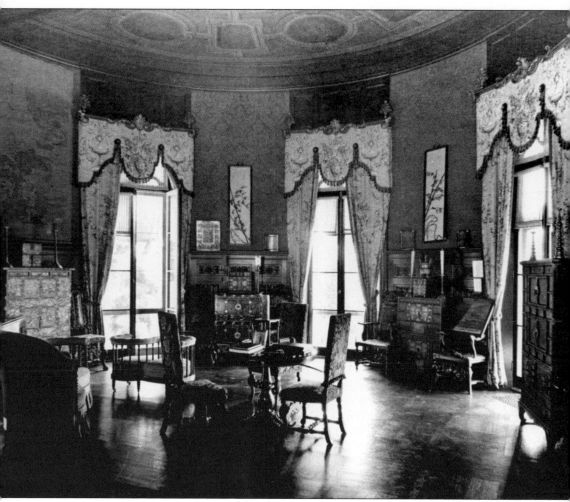

Seen here is an intimate reading room. Isabel made her career as an author and published many books. Her most popular were accounts of her travels, but she also wrote plays, poetry, and even children's books.

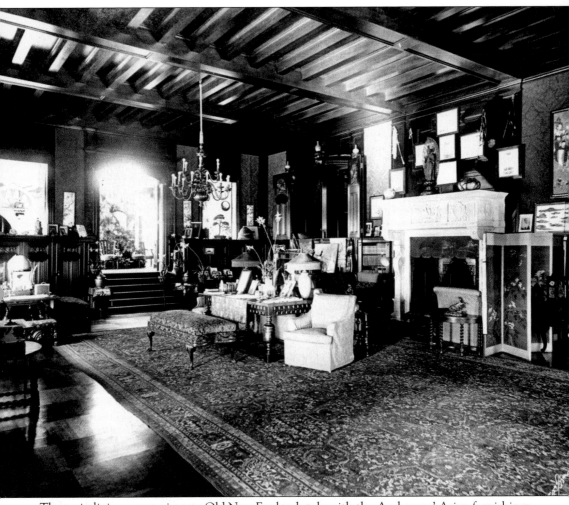

The main living room mixes an Old New England style with the Andersons' Asian furnishings. This pairing gives the room a more distinctive feel than much of the rest of the house.

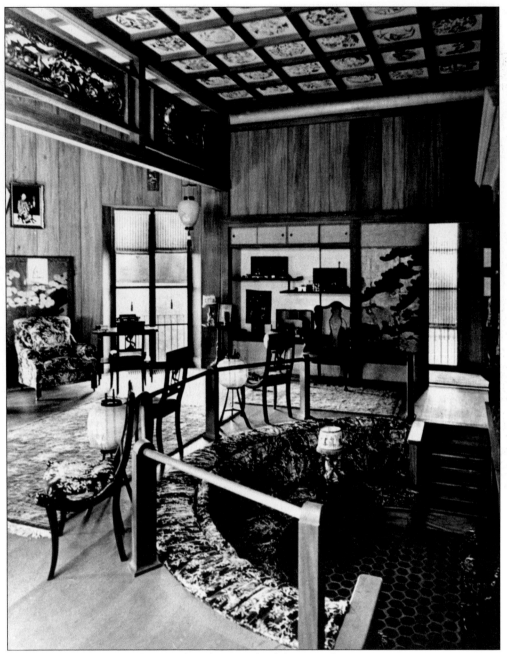

More Asian styling is evident in this photograph of the main living room.

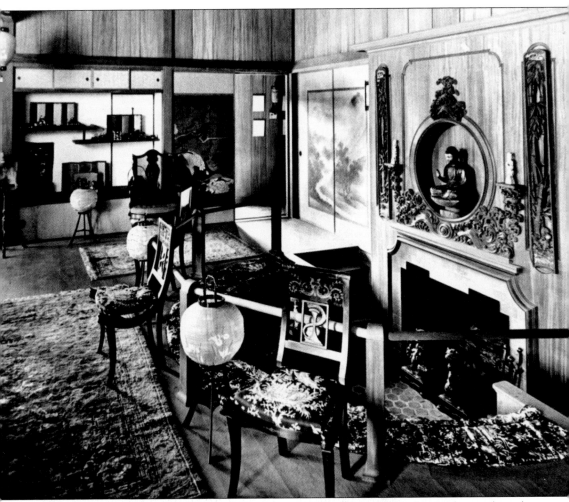

Asian lanterns and figurines appear above the sunken fireplace. Again, the Andersons brought the experience and feel of their gardens into their home, where they could be enjoyed year-round.

Six

A PARK IS BORN

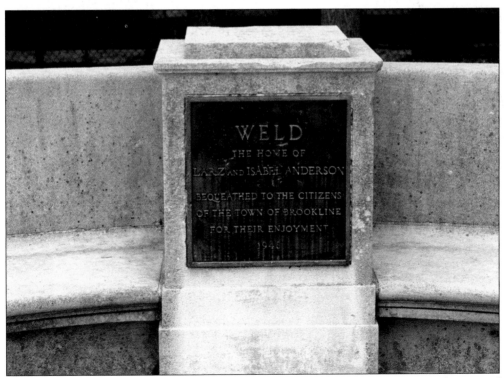

Upon Isabel Anderson's death in 1948, the estate and all its contents were given to the town of Brookline, with the stipulation that it be transformed into a community park. It would be made more useful to the townspeople, while still maintaining the beauty and grandeur of its fame.

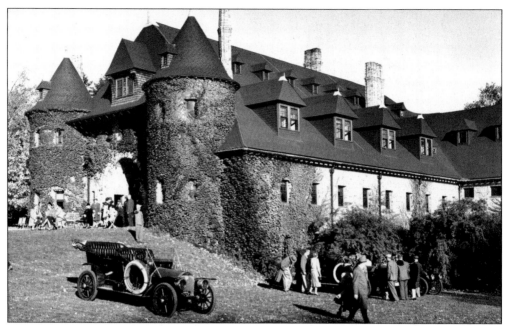

The opening day of the Larz Anderson Auto Museum occurred in 1952 under the control of the Veteran Motor Car Club of America. As the nation's premiere old car club, it was well equipped to care for the cars.

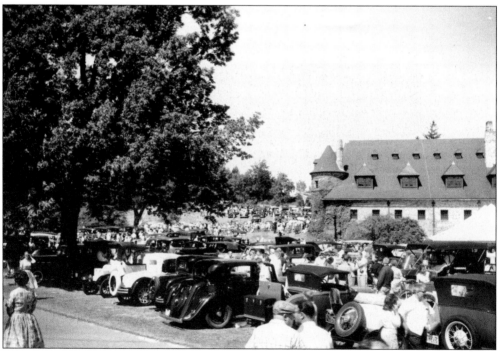

At this bustling dusters meet in 1962, the lawn is full of cars and spectators. This spot continues to play host to car shows throughout the warm-weather months. The car shows are the largest source of visitors to the park today.

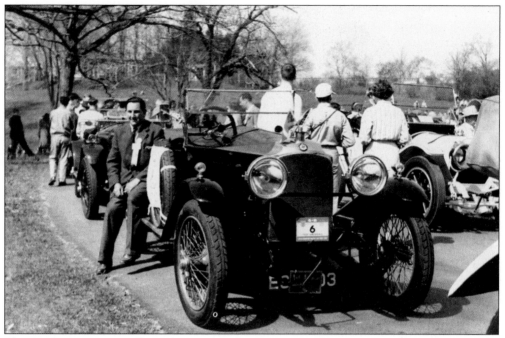

The Anglo American Rally made a stop at the museum in 1958. A team of British antique car enthusiasts came over to participate in this high-profile event.

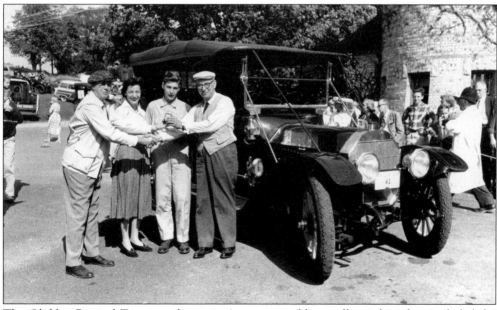

The Glidden Revival Tour was the nation's premiere old car rally, and it often included the park in its route. Seen here is an award presented at the 1958 tour.

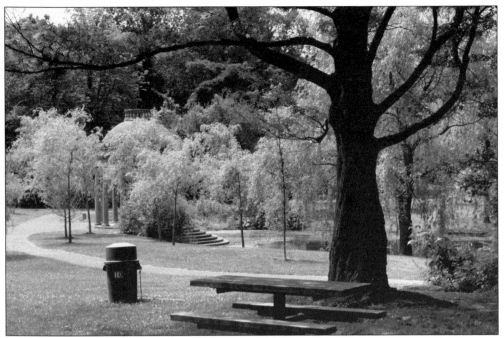

This view depicts the water garden today. One of the most unchanged parts of the park, it also remains its most recognizable feature.

Picnic areas were added near the polo field to make the park more useful to the community.

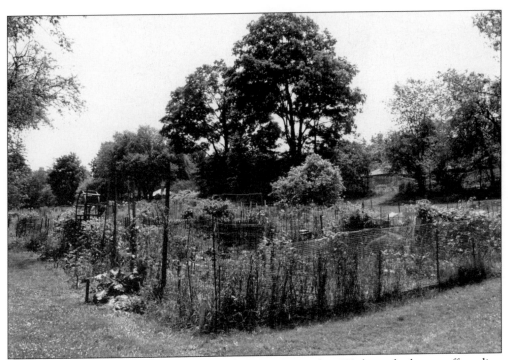

The Chinese garden has been replaced by a community garden. Without the large staff tending to the estate, many of the features fell into disrepair and were converted to other uses.

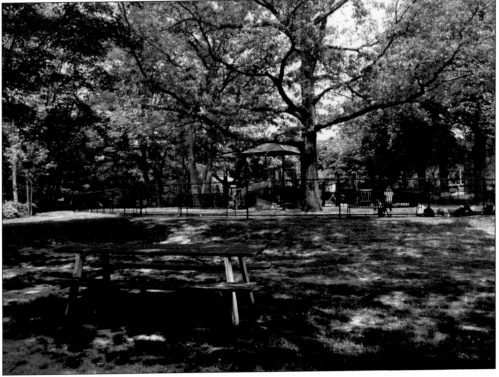

Playgrounds were also added to the park.

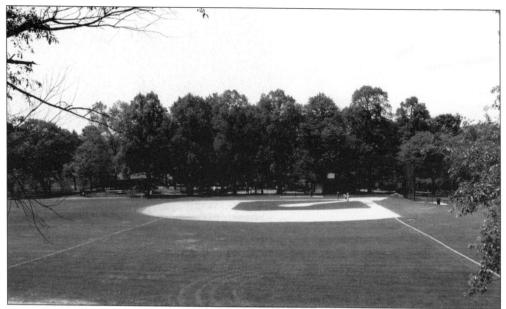

The polo field was converted to a pair of baseball diamonds.

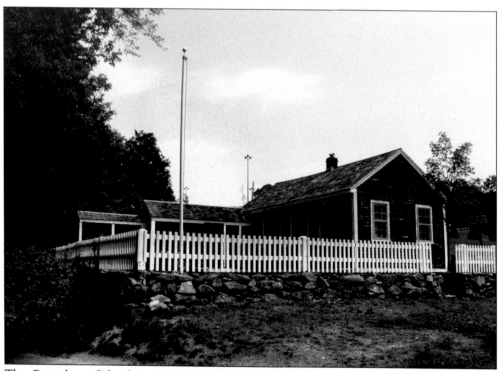

The Putterham School, a one-room schoolhouse originally located a mile away in the Putterham region of Brookline, was moved to the park in 1971. The school is opened to visitors occasionally during the summer.

The alley has remained relatively unchanged these 100 years. The trees still form four straight lines.

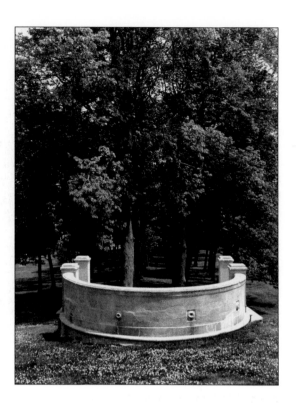

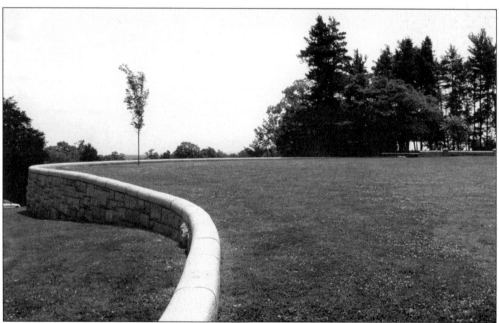

Seen here is the foundation of the once-grand manor. After the death of Isabel Anderson, the house was left vacant and quickly fell into disrepair. By the mid-1950s, it had been vandalized and partially burned. The town decided to tear the structure down. The land was grassed over, and a small parking lot was built.

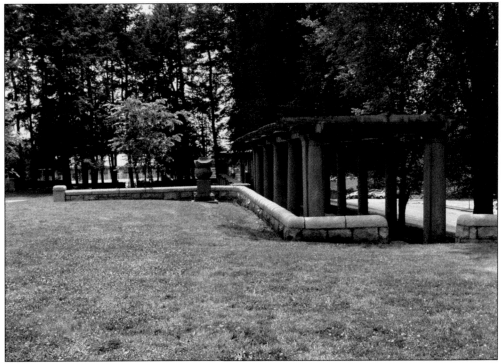

The colonnade still stands, giving visitors a hint of the grandeur once present in the park.

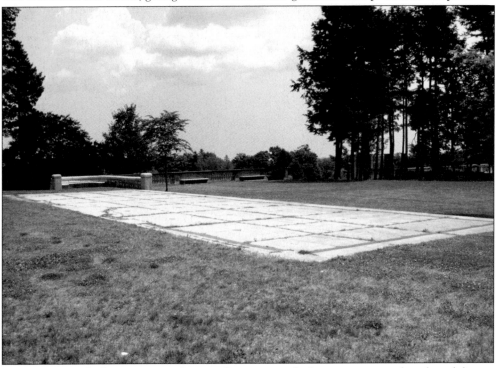

The patio from the house remains. It was a favorite spot for Larz to entertain friends and discuss politics over a cigar.

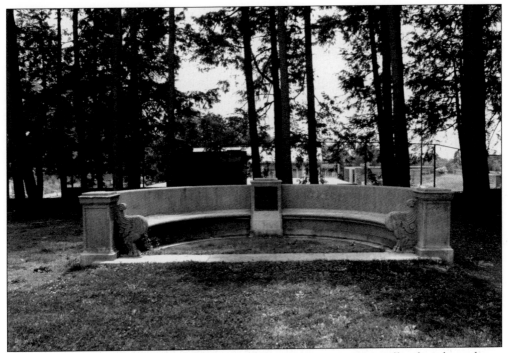

This seating structure once stood adjacent to the house. It is now affixed with a plaque explaining the Andersons' gift to the town.

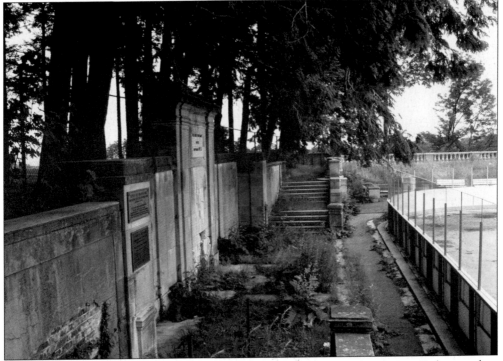

Perhaps the part of the park most altered from its original use is the glorious Italian garden, which is now an ice-skating rink.

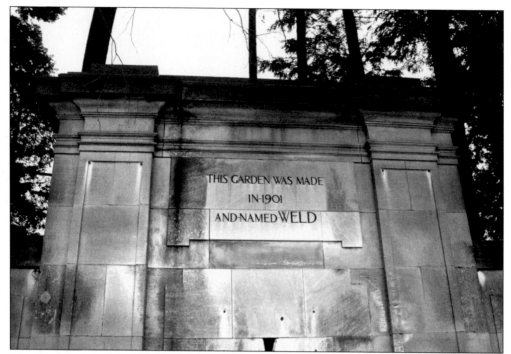

THIS GARDEN WAS MADE
IN·1901
AND·NAMED WELD

The ice-skating rink was built in 1958, a time of progress when not as much attention was paid to historical structures.

The original well still stands, though the inscription has become illegible.

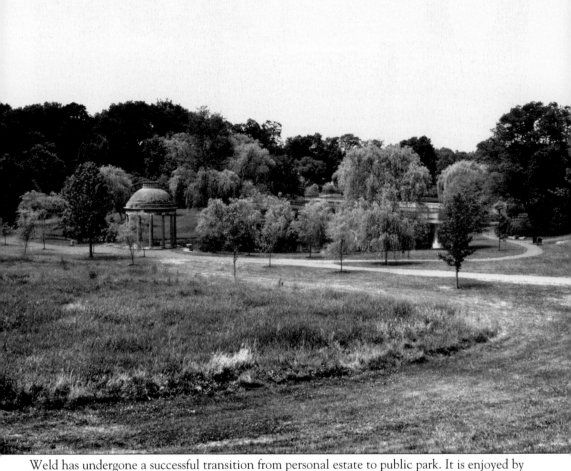

Weld has undergone a successful transition from personal estate to public park. It is enjoyed by the local community and by visitors from around the world. It remains an oasis filled with quiet places and green spaces where one can go to escape the surrounding urban area.

ACKNOWLEDGMENTS

Thanks to the staff of the Larz Anderson Auto Museum for their support in the creation of this book. Thank you to the town of Brookline for its continued efforts to return this park to its past glory. And lastly, I am grateful to Jennifer Hayes for all of her editing and assistance.